Inside the Studio of R. H. Ives Gammell

An artist's daily notes, recorded during the Summer of 1976

Inside the Studio of R. H. Ives Gammell: An artist's daily notes, recorded during the Summer of 1976
by Allan R. Banks

First published in 2019 by Abbey Brooke, LLC

ISBN-13: 978-1-7923-0451-4
First Printing, 2019
Printed in the United States of America

Banks, Allan R.
 Inside the Studio of R. H. Ives Gammell: An artist's daily notes, recorded during the Summer of 1976 / by Allan R. Banks.
 ISBN-13: 978-1-7923-0451-4
 ART000000 ART / General
 ART016000 ART / Individual Artists / General
 BIO001000 BIOGRAPHY & AUTOBIOGRAPHY / Artists, Architects, Photographers

Library of Congress Control Number: 2019902309

Allan R. Banks

Inside the Studio of
R. H. Ives Gammell
An artist's daily notes, recorded during
the Summer of 1976

ABBEY BROOKE

Dedicated to Richard F. Lack, artist and mentor,
for providing a solid artistic foundation.

Table of Contents

"You never cease trying to improve your interpretation of form. That struggle never ends."
Joseph DeCamp

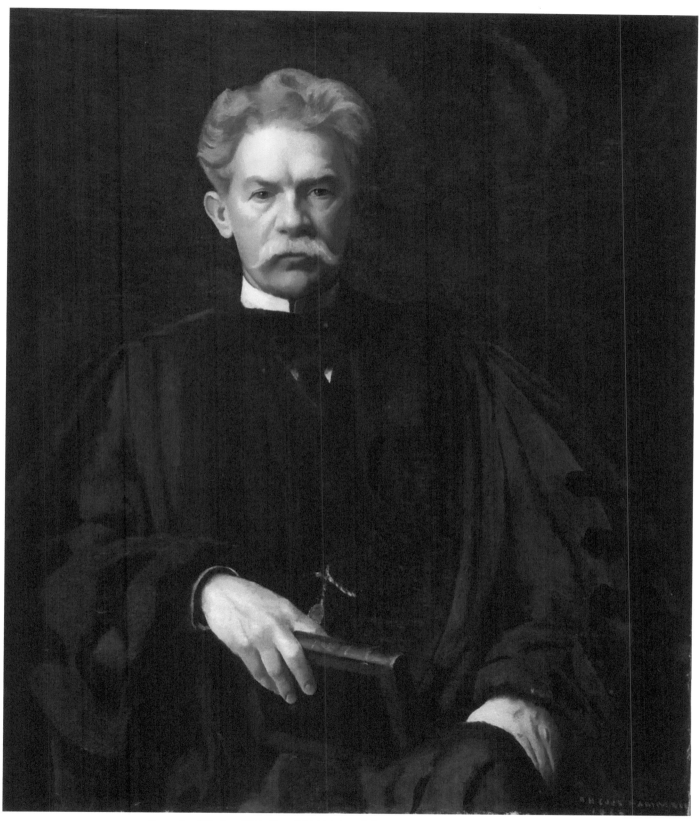

Portrait of Herbert Weir Smyth (1857-1937), by R. H. Ives Gammell. Harvard University Portrait Collection.
Gift of Michael Carman to the Department of Classics, Harvard University, 2004.

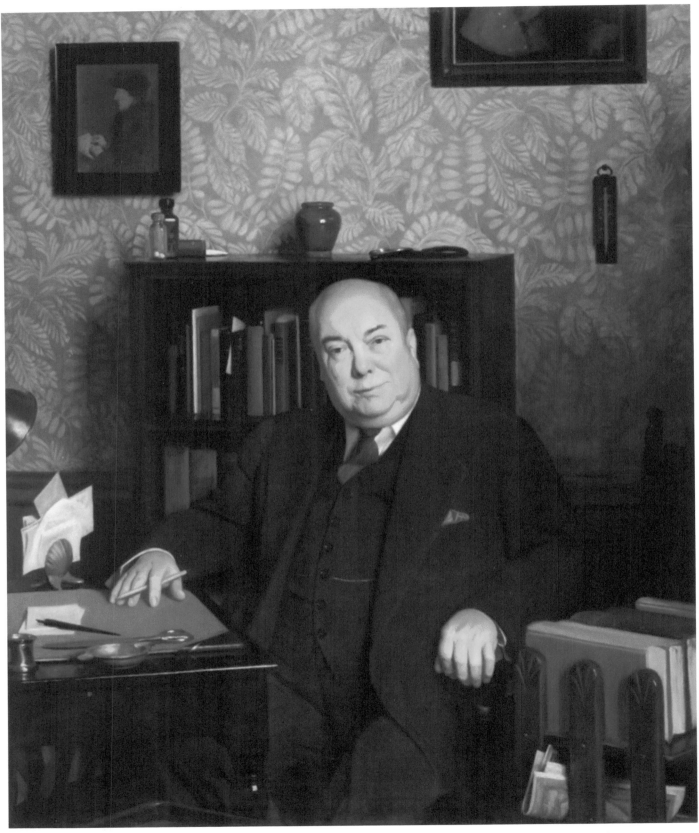

Portrait of Roger Irving Lee (1881-1965), by R. H. Ives Gammell (1954). Harvard Art Museums/Fogg Museum, Harvard University Portrait Collection, Gift of Roger I. Lee to the Harvard School of Public Health, 1954, H547.

Acknowledgments

A life deep-rooted in the Arts is without question a euphoric experience, most particularly when a firm foundation is established. I gratefully experienced that under the watchful eye of Mr. Richard Lack and a short time later with Mr. Gammell. I thank God for that honor, knowing the trials and rewards that accompany our chosen profession. Hard work and persistent study net the benefits artists enjoy from traditions handed us by the Masters. Generation after generation, the stepping stones become ever more valuable and I am reminded of William Paxton's words, *never get 'cheeky' with the Masters, for they earned that status for a reason.* Thus, we study them humbly and reverently to uncover what secrets may be learned.

So, my gratitude must first be with Mr. Richard Lack, who upon beginning his own atelier, I was among the first generation to benefit from his superlative teaching. Then to Mr. Gammell, for adding yet another dimension to my own study. He led me toward a rich understanding of the great and noble craft of picture-making with unequivocal emphasis on no shortcuts just do a 'good Job' at each and every phase. Mr. Gammell elegantly reestablished these truths in his publication, *Twilight of Painting*, a pivotal book for artists, printed in 1946 - exactly at the right time.

The published book of notes contained herein would not have been possible without the encouragement and thoughtful advice of my lovely wife Holly. Her efforts to locate and read the notebook, type it up and then insist I share what was said was invaluable. It provides a glimpse into my studio work done with Mr. Gammell during that splendid summer of 1976.

A special thank you to Darren Rousar, artist, author and instructor, who skillfully organized and clarified what the notes seem to suggest so the reader could coherently follow my daily note-taking. His published books for artists continue an important legacy with further insight into the tradition preserved through Mr. Gammell and Mr. Lack.

The notes are not a treatise on painting, nor a complete treatment on the artists we discussed in the studio milieu. Rather, they are about one man's summer efforts with a charming, tough, charismatic elder gentleman and painter well-versed in all the arts who had a willingness to share that lifetime of knowledge.

Along with *Twilight*, Mr. Gammell published other books including *The Shop-Talk of Edgar Degas*, and the biography, *Dennis Miller Bunker*, all the while providing personal tutoring for talented aspiring painters to preserve a legacy otherwise lost forever.

My deep appreciation goes additionally to the following individuals and institutions who lent their support on this project. The Daniel Chester French museum, the National Trust for Historic Preservation, Stockbridge, Massachusetts, Dana Pilson, Curatorial Researcher, Chesterwood, Photography courtesy of Don Freeman, Harvard Art Museums Cambridge, MA, Images from the Metropolitan Museum, NYC, The Smithsonian American Art Museum, Washington DC, and Vose Galleries, Boston, MA. Contributions also came from Tom Dunlay, Liz Hunter, Suzanna Lack, Carl Samson, and Richard Whitney, with an added appreciation of the continuous comradery within the Classical Realist movement itself: Artists Steve Gjertson, Kirk Richards, and Gary Christensen working tirelessly toward the goal begun with Mr. R. H. Ives Gammell. Special mention additionally to Mr. Fred Ross, Businessman and founder of ARC; Art Renewal Center, who traveled with me to visit Mr. Gammell in Boston to get his blessing on a plan we hoped would aid future preservation of our shared passion for artistic revival.

The Clouds Return After the Rain, by R. H. Ives Gammell (1934).

How the Notebook Came to be Published

When I entered the studio for study with Mr. Gammell in July of 1976, I knew it was a momentous event. I therefore took seriously the time and effort he would invest in my training over the next few months. I also wanted to be sure to record all I could in order to preserve the instruction I would be given. I did so virtually daily.

It never occurred to me to do much more with the Notes except to refer back to them later on. Once the dust settled and I was back home in Ohio, scurrying around for portrait work and planning paintings, the Notebook was set aside. I was hurried because Richard Lack's upcoming group exhibition was being organized, and needed work from me. Richard Lack was my mentor, also a former student of Gammell's from years earlier.

From time to time I did pick up the Notebook again, and when I reread it I could hear Gammell's voice in my head. I treasured the Notes. After several moves to other states, including New York and later to Florida, the book was tucked away in a box, sealed up, and forgotten amongst miscellaneous books and papers.

I thought for sure the Notebook was lost since I hadn't seen it for some time. That is, until just recently in 2015 when my wife Holly was unpacking some old books. She said to me, "I think I found the Notebook you always talked about but had lost," and she set it down in my office closet. Eureka!

As we read it together, Holly said, "It seems like Gammell is right here," and she urged me to get it typed up and saved for fear that it may be lost once again.

So, realizing that I may be the only former student, at least to my knowledge, who actually took extensive notes under Gammell's teaching – it seemed a good idea to pass it along in the hopes that it may be helpful to students or others. It represents a period in my history, working alongside a legendary painter who kept a legacy alive over the very dark days of the modernist era.

Finally, it's here and I did not make changes except to clarify a word or two from my own lingo. Since much of the note-taking was very fast, and done either immediately after Gammell gave a critique or otherwise at night before retiring, the wording is a bit jumpy in places. Remember, however, this was done primarily for my own use and not intended for publication.

I hope you will find something of value here and there. Some of it is personal, some of it instructive, and some of it is just a time capsule of a summer in 1976 with Mr. Gammell.

I am grateful to have worked under R. H. Ives Gammell and promised him I would do my part to continue his legacy.* Little did I know that it would include an old Notebook.

*Gammell too, in his senior years, was preserving his own mentor's legacy while I was with him. His published manuscripts of *The Twilight of Painting*, *The Boston Painters: 1900-1930*, *The Shop-Talk of Edgar Degas*, and *Dennis Miller Bunker* are examples of his authorship.

To the painter, born or unborn, who shall lift the art of painting from the low estate to which it has fallen, this book is hopefully dedicated.

-Gammell's dedication from his book, *Twilight of Painting*

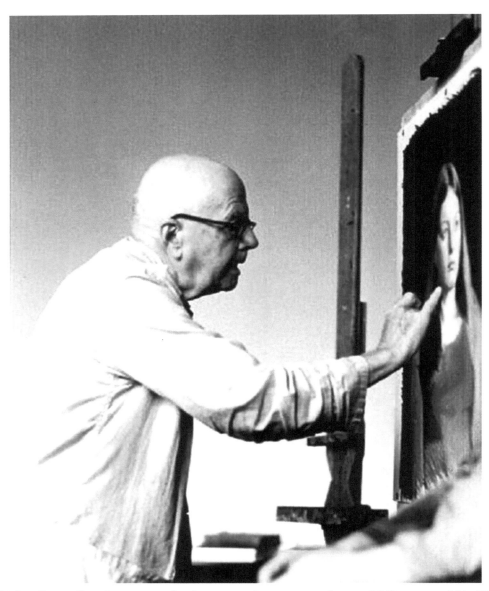

R. H. Ives Gammell working on a student's picture, at his private residence in Williamstown, MA. 1976.

Preface

R. H. lves Gammell and I initially met on Memorial Day weekend in 1976. Prior to our meeting, I was in New York City visiting a friend, Charles Pfahl, who was making quite a name for himself. He had offered the use of his studio for that summer because he planned to use another studio in the city for some project he had. The offer intrigued me enough to make the effort and go.

I had already been teaching and taking on portrait work in Ohio when Charles and I first met. We also shared a Gallery affiliation in Medina, Ohio at Gallery Blue. As we got better acquainted he suggested that I come to New York and to think about relocating because his studio would be available.

My early training as an artist, which lasted nearly four years, began with one of Gammell's former student's, Richard Lack of Minneapolis. Lack had studied with Gammell years before, so I was quite familiar with Gammell prior to my weekend visit to Pfahl's place.

It was on a whim, however, that I thought to phone Gammell and introduce myself. If he would see me I would make a short trip to Boston from New York and back again. Gammell answered the phone and he was very cordial, asking about my background and how long I had been with Richard Lack. He said, "Well, I am a very old man but why don't you come to Boston for a visit – this Monday at 10 am." I agreed and was overly excited just to hear his voice and the possibility of meeting the man-artist-author.

Even prior to entering Lack's atelier, Gammell's book, *Twilight of Painting*, had become my bible for art from the first moment I read it in 1967, while a student at The Society of Arts and Crafts in Detroit Michigan. Since my copy had no dust jacket on it, I assumed that it was from an earlier time and did not realize he was still very much alive. At the time, from the forties to the sixties, the general art scene had declined to such a low ebb that anyone looking to paint anything resembling the great masters was scoffed at in colleges and art schools.

Fortunately, the Detroit Institute of Art was located a few blocks from the school. It had an extensive collection of great academic art by such artists as Bouguereau and Gérôme, along with several of Sargent's works that I studied almost daily. So I was keen to find anyone that could approach that level of quality. After finding Gammell's seminal book at the art library nearby, I was hooked by the man's clarity and conviction to return art to the high standards it had once been. His book opened up a new world of fresh air and common sense for me. It gave me the courage to wholeheartedly reject the then current tide and to seek out academic artist-teachers – that is, if any could be found. And, of course, I found Richard Lack who I understood had studied with the great man.

Our first in person meeting took place in Boston, at his suite of studios in what is called The Fenway Studios. I showed him a sample portrait and we discussed my background studies with Richard Lack and the atelier training there. He then suggested I work with him over the summer at his Williamstown Studio, which was west of Boston. He proposed to help me to hone my skills with portrait work and landscapes. I eagerly accepted the invitation and was extremely anxious to get started. Being with the great painter and a few of his other students (Tom Dunlay, David Lowrey, and Jan Posvar) in a very private elegant environment was to be one of the highlights of my life.

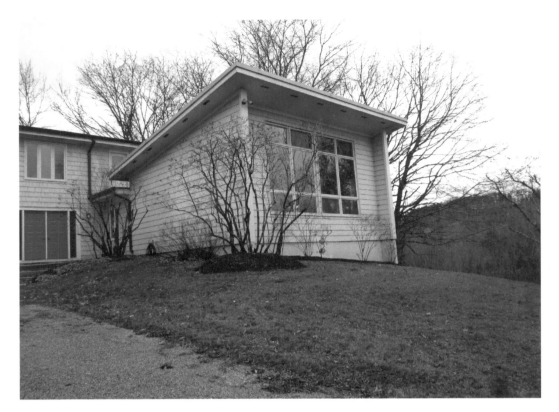

Photographs courtesy of Carl Samson.

In 1966 Gammell built a summer studio-home in Williamstown, MA (shown above, in 2015). The property had two studios for students in an adjoining building (his own studio was within the residence). He would often leave his studio and come over to our studio-rooms to pop in and make comments etc., and to review our works. Another benefit was that the Clark Museum of Art was only a few blocks away.

Williamstown, Massachusetts
July, 1976

July 4,1976, Sunday - 3:20PM

I traveled to Gammell's residence in New Hope Park, which is a subdivision of Williamstown, Massachusetts.

The first meeting with Gammell was one of getting better acquainted and explaining exactly how I came to study with Richard Lack, etc. He was surprised to learn that one of his former student's was not entirely accurate about his background, or so it seemed to me, because he carefully compared my story to what he was told.

Just prior to my arrival, a student had abruptly left the studio. It seems that he had chosen to marry but did not know how to tell Mr. Gammell. So he simply left.

We talked for about 45 minutes. He then suggested that I see David Lowrey and Jan Posvar, who were in the adjacent studios. Between Dave, Gammell, and myself, we worked out an arrangement for setting up a portrait and scheduled landscape times. Gammell always had meetings with us to plan our day.

I left Gammell's at 6:40PM

July 5, 1976, Monday - 10:30AM

Staying in a boarding room at Mrs. Lally's home. (She often hosted Gammell's pupils).

Notes to get started:
- Keying a landscape was a late development as an art form.
- Leonardo did monochrome landscapes which were merely "adjuncts of picture composition."

In the 19th Century, and earlier, landscape paintings were pictures of landscape done from drawings. Artists back then used white for the sky then worked down to the next tone, from the light. The gradual working method virtually became black as the foreground was developed. It was very unpleasant in effect.

Corot first recognized errors in seeing landscapes (regarding plein air painting as practiced at the time). Gammell credits Corot as the true father of plein air painting. He advanced both the proper key and the relationships of tone as seen direct from nature. This was the opposite of studio productions which were primarily composed of contrasting tones. One can see this in the works of Turner, the English painter who was slightly older than Corot.

Indoor landscape painting done in the studio does not correlate with painting outside.

Keying was not favorable to indoor seeing. Mr. Gammell said that "you cannot make it as brilliant as sunlight," so artists began to key up. Relations in color can be matched when working indoors – but not so outdoors. Out-of-doors painting may be arrived at by working dark to light.

The conclusion: Key the sky to get the characterization for the day and then attempt to relate the entire key to it.

Hawthorne was first in the U.S. to prophesy the impressionist approach. He was an instinctive artist, a pupil of Chase (1880-1919), and was somewhat misleading because he misinterpreted painting. His work was often keyed up, too sweet, and very 'candy-colored'.

Chase was generally superficial, not a draftsman, not much form to work with. He seldom developed solid modeling of his figure work but was instead generally very sketchy.

The closest to the impressionists were Americans, they went directly to Monet, then back to Boston and to Gammell (and his students). After 1930 the approach to solid training declined radically.

The indoor palette is based on earth tones particularly.

The out-of-door palette is based almost entirely on cadmiums, with the addition of ochre – which was the only earth color used.

Cremnitz White is the whitest of the three-not available.

Flake White is the only one useful. #2 has the consistency.

Zinc tints do not have body. (Not to be used) Bad drier.

Cadmium Colors

2 Yellows: Cadmium Pale and Yellow Ochre

2 Reds: Cadmium Scarlet and Alizarin Crimson (Alizarin is acceptable)

Avoid the overly 'hot colors' and sweet unnatural coloring.

This is what greatly influenced me to go after the cooler palette in my own work, which is also obvious with both Corot and Monet.

The Lake colors are not as useful

Red-orange – the pales are not as beneficial.

2 Blues: Cerulean Blue and Ultramarine Blue

Before excusing myself at 11:05AM from Mr. Gammell and Jan, Mr. Gammell suggested that we meet again at 1:45PM, at which time he would begin a demonstration landscape. We were directed to a high point near his property which overlooked a valley and some rolling hills.

1:45PM Demonstration:

We gathered and then drove to a mountainous site. Mr. Gammell asked one of the three of us to clean the tubes off as he squeezed out the paint.

Gammell was fastidious about cleanliness, even of a tube of paint. He wore Playtex gloves due to skin rash problems he had developed over time. His energy at 83 years old amazed me on that very warm sunny day.

He sat on a small folding chair with paint box on another. Then he commenced.

He had a very light tone on some sized (primed) paper. The average size for these studies/sketches were 12" x 16".

The sky was first established using white, a very light cerulean blue and a trace of scarlet red. He used a criss--crossing, up and down stroke. After carefully preparing the sky (by smoothing and simplifying shapes), he brought the edge of the sky below the expected mountain region. He would paint the edge overlaps, wet into wet, later.

During the demo he stopped and dipped a thumb into a clean blue hue which he then placed onto the landscape toward the middle of the sky. He stated that it was as a pure color note which subtly complemented the whole sky. He said it was a well-used little device to harmonize.

Gammell often shared the insights and little devises employed by his mentors and this was one he thought of when the sketch was fairly complete. He said, almost humorously, to complete the 'icing on a cake' finish. His delightful way with both words and instruction felt very old worldly Edwardian to me.

Gammell stressed that the canvas should be entirely covered during the first 1/2 hour.

He then began painting the mountainous region at the furthest distance away from us.

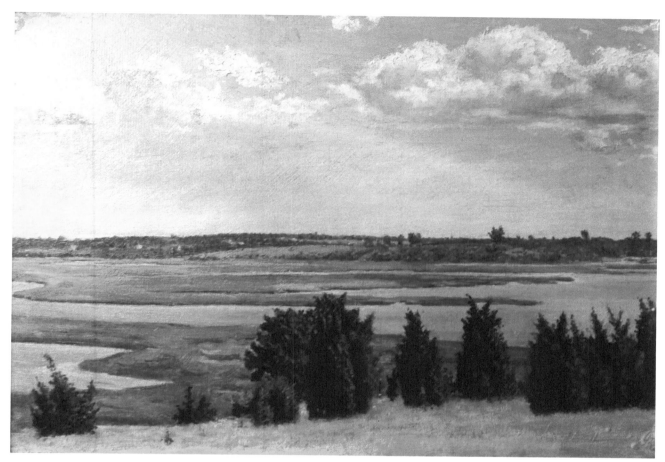

A landscape painting by Mr. Gammell.

Then, from the distant mountain area, he proceeded to paint the foreground. He stated that a relationship was needed and to proceed with the foreground first, before attempting the middle-ground and darkest area. The middle area is then worked in using a variety of subtle color notes.

Painted strokes are broken and carefully placed, which gives a beautiful quality of color nuances when painted over again.

Upon taking up a painting on another day, a (Winsor Newton Dammar) retouch should be utilized before painting on the picture.

Gammell sat there, painting in 80 degree-plus weather at 83 years old and continued without break for 2 full hours. I was very awed by his staying power and his exceptionally keen observations of color. His hands were not as steady as perhaps years before, but without question he handled the paint delicately, decidedly, and anticipated each move. During the session he stated over and over that at any moment he would soon be stopping. But as the picture progressed, and it progressed very well, he became more earnest at doing as much as possible to capture nature. This always animated him and drove him to do a thorough job.

Often, Mr. Gammell quipped at certain occurrences he saw in nature, "Oh, look at that absolutely lovely lavender near those trees!" (while gesturing to an area in the background).

His manner while painting, before and after, was to be very orderly and neat at all times. Each tool used was quickly returned to its proper placed after use, except the brushes of course which were held in his hand. Placed in palette hole were wiping rags which were cut to a small size. These were utilized and then tossed away when they became too filled with paint.

At all times when painting he wore gloves and although they seemed somewhat large, he never the less used them with dexterity. He also wore a hat to sufficiently cover his eyes from glare and suggested it was a necessity. He was quick to point out at the onset that 'standing' was the accepted way to carry on painting, but he sat so he could use his energy most efficiently for painting the landscape.

After the session ended, we climbed back into the car (Gammell's Buick station wagon) and went directly to his studio to view his picture under studio light. Needless to say, it was most impressive and lacked little for finish. He excused us and I remained for a few minutes to talk about how to schedule the remaining week and to discuss what areas he thought I should work on. We decided on 3 portraits as well as doing some landscapes. I was also to read some of his old books and his own transcripts. Naturally, I poured through them.

Following that meeting, I went back into the studio, grabbed my paint box and set out to dinner. After dinner I went onto Mount Grey Lock reservation and stayed from 6:20 to 7:30. I worked on a landscape which overlooked many miles of rolling countryside.

July 6, 1976, Tuesday

I arrived at Gammell's at 8:15AM and waited in the adjacent studios until 8:30. I then drove Tom Dunlay and Jan, and I went in to see Gammell. As usual, Mr. Gammell asked us what our plans were for the day, and if Dave was going to prepare a box for the model to sit on. The model was supposed to sit for me on Wednesday morning from 9-12 noon. A young girl, named Lori, was our summer model for the first portrait sittings.

He asked Jan to do up a few small thumbnail sketches – 3" x 5", pencil on paper of some landscape scenes.

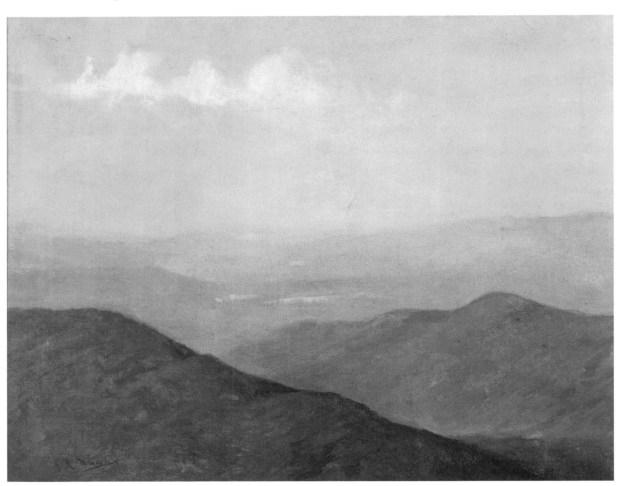

Grey Lock Mountain, by Allan R. Banks (1976).

Tom Dunlay worked that morning with Dave on a portrait of young Andrew (12 years old and boisterous).

Gammell then asked if I had accomplished a landscape. To which I replied an affirmative, so he suggested I bring it in to show him. He then dismissed the others. As he looked at my landscape sketch (a Brook-bridge landscape) he asked what exactly was my intention in doing the sketch. After pondering the question momentarily I said, "The overall color ensemble." Then he said to recheck the relationships and to improve the composition.

The Grey Lock Mountain landscape was shown to Gammell after the morning studio session, as was the field sketch that afternoon. On looking at my paintings he mentioned the composition, relationships, and other tips to look out for.

The Grey Lock scene was met with approval and had "some very nice things in it." What I needed at that point, rather, was hard criticism. He was not as severe as I thought he might be. However, he made a good point about not repeating areas as I had done in the clouds and to the mountain strips.

After the noon meeting I proceeded to the Hope Park area to sketch in a very nice rock formation and some water streaming under a large bridge. I did several smaller studies there.

At 5:00PM I returned to studio. Dave and I were guests for dinner at Andrew's home. We also cut wood for a model stand and then put it together after 8:30PM.

We worked to about 9:00PM. I then went home, briefly talked to Mrs. Lally, and retired around 11:00PM. Mrs. Lally looked forward to learning of my daily routines with Gammell.

July 7, 1976, Wednesday

Get a cleaner approach to working (more organized, simpler).

Gammell noted that painting instruction was ruined by large classes, which began in 1930, causing artists to have little time to get help and to have their work criticized constructively. Gammell often criticized class sizes which were too large for painters.

Memory Drawing.

The training of the memory is everything. Formal instruction in memory drawing began in the 1880's or 90's. Degas reacted against memory drawing not being used enough; Gammell talked about this later as it is important. John Sargent also utilized it early on in his training.

Gammell began memory drawing exercises at Paxton's in 1922.

A system for memory drawing – do at least 20 minutes a day.

Portrait Painting.

Work in life size only, not monkey size (a favorite term used to stay in appropriate relationship) – small is offensive in portraits.

Mr. Gammell likes testing us with curious side observations and historical remarks, anticipating out response. He smiles as he does it and I enjoy it.

William Morris Hunt was a great painter, he liked ladies classes.

Read Talks on Art by Hunt.

Utilize brown paper in studies as it is inexpensive. Working on a large cut piece of 28" x 22" and later using strips of the paper for size trimming.

The information above is incomplete because Mr. Gammell talked quickly about a couple of items. He did not complete either explanation because my model was soon to arrive and finally did within 15 to 20 minutes.

Gammell loaned me his book (which he wrote), *The Shop-talk of Edgar Degas*, that afternoon.

Part of his talk dealt with Gammell telling me that Sergeant Kendall was a very fine artist, however, he was an ass as a person. He did not correct Gammell's work as Gammell felt he should. Instead, Kendall would simply look at his cast drawing alone, not comparing it at all to the cast itself. This infuriated Gammell who wanted to know exactly what should be done and how to see the shapes correctly.

Gammell said of himself that he is not a natural draftsman because he felt very weak at drawing. Due to that belief he decided at the age of 38 to stop everything and learn to draw. He turned to Paxton for help. Paxton said that this was the smartest thing he could do. So, he worked with Gammell and 2 others on drawing every Monday for 4 years.

Paxton was a great draftsman. During that time, while looking through a comprehensive book on drawings of the Renaissance, Paxton said, "He (Paxton) could draw more accurately than anyone in that book except Leonardo, but they were better artists."

At the same morning talk Gammell looked at the new landscape study I had done the evening before. He seemed to like it very much and said that it was a lovely and interesting picture – and that I was to continue working on it but at a time when he could be there as well.

Following that brief but very helpful meeting, I returned to the studio to begin arranging my model. Gammell told me to do this in my own way first, then get him to look at it.

When viewing the set up he said that he liked the general background effect, but suggested I get the canvas in better light.

Nude, pastel by Sergeant Kendall. This pastel was owned by Richard Lack. It is currently in the collection of his daughter, Susanna Lack.

"Now did Richard Lack explain to you how Sight-Size worked?", he asked. I said he had and proceeded to say that the easel should be in the middle of the head and next to it. But I made the mistake of saying it should be life size or under, to which he said, "NO! NO! Life-size or larger! We do not want to make something look to be monkey size. And it does not flatter the sitter at all – for formal work done on large canvases the head sizes should be larger."

I proceeded to lay-in the portrait with charcoal until noon. At noon, I went to the Clark Museum staying for an hour.

At 1:45PM, we again visited Gammell. The weather looked very overcast and was raining slightly.

Jan and I were asked what we planned to do, to which I said "to paint a landscape."

I then began working on a landscape. When Gammell was on his way to look at my picture sometime later, it rained heavily so he went inside and I returned to the studio also. I worked on a field study of a rainy overcast sky.

July 8, 1976, Thursday

Today I arrived at 8:15AM. At 8:30 we proceeded to Gammell's studio. The meeting did not last long, about 10 minutes. He said he would be in my studio to check things out regarding the portrait.

As he viewed the portrait with the girl, he suggested using straight, narrow strips of brown paper, cut 2 to 3 inches wide by 24 inches long, to frame the size of the picture. Another area was the

blouse which happened to be white. It needed much work. I was to look at what's there and find those subtle areas that would 'amuse' the eye – something like a particularly interesting curve of the sleeve. Also, to pay attention to design as it nears the edge of the picture plane.

The Portrait Lay-In:

Develop the lay-in of the background by carefully outlining the hair, or any area exposed to it. The lay-in should be sufficiently thin to limit any excessive buildup of pigment in any area. Establishing the key of the local color in its 'bigness' should be the intention from the onset.

I spent a great deal of time doing as suggested by Mr. Gammell, in designing the areas as they would 'amuse' me, which means any interesting area just occurred to excite, a sudden but well thought out change, such as the sudden slope of the arm, or the turned up collar, etc., – whenever such a thing should occur, as a point of interest.

At no time did Gammell insist on a his personal viewpoint. Rather, he was watchful only for jumping the gun before more important items were established.

He said, "Never go backwards in your procedure."

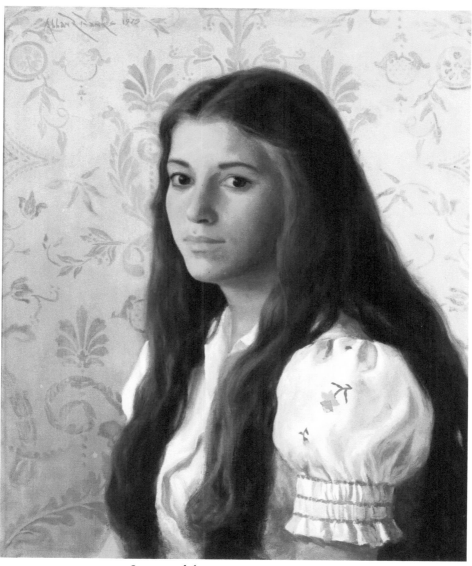

I presented this portrait to Mr. Gammell as a sample of my abilities.
It was painted in my studio in Ohio, after my studies with Mr. Lack a few years before.

July 9, 1976, Friday

Vibert Varnish was the best for all the qualities needed. It was formulated in the 1880's but about 8 years later it was changed. 1 part dammar varnish to 1 part turps is a suitable substitute. Gammell lamented over the inferior products being sold to artists. Mr. Gammell was very reluctant to swear by any product now being produced.

He recommended that I look through one of his books on Ingres, particularly for the linear quality in designing and re-designing passages.

Our meetings were had as usual.

I was working on a landscape I had begun a day or two before. Gammell said that I should lower the key to correctly indicate the mood of the day. When I left, the impression in the painting study was complete, save for detail work.

July 10, 1976, Saturday

Since it was Saturday I slept in to 10:40AM at which time I was thinking about going to Pittsfield to visit the museum which I understood had two Bouguereau paintings. First I went to get a coffee and 4 donuts.

On the way I heard Dave call to me from the car as he passed by. The Williamstown shopping area had a small, quaint little center. At the time, a puppet show was going on, with children gathered, along with their parents. When Dave spotted me, I was walking along looking at the shops. He caught up with me and said, "We meet on Saturdays," to which I was surprised. I then saw Gammell who also wondered where I had been. After finally understanding the weekend duties, I proceeded to the Clark Art Museum to view all the very impressive pictures there.

At noon, I was back at the studio and would wait there until 1:45 in order to see Mr. Gammell again. While I waited, Dave, Jan and I chatted about another student, Detroit and its problems, and other areas somewhat amusing, like student personalities.

1:45PM

We met with Mr. Gammell and then Dave went out to landscape paint. Jan retreated to the nearby hillside to begin his first landscape painting and I, as suggested, went to the base of the hill to rework my 'five-finger' exercise (our term for doing landscapes).

Gammell made his rounds from Jan to myself at about 3:30. As he viewed my picture study he was happy to see I was 'getting' the idea very fast. He said that I had covered a great deal of ground in less than a week and he congratulated Richard Lack for having done so much for me. Further, he stated that he felt as though I had been there much longer. "And that's a compliment," he said.

I found throughout the week that Gammell was very keen to intelligent and rational observations. He also held that proper working habits were crucial to proper picture making, as well as always improving as nature demands, through its variedness. You cannot design better than Nature so use it to the max. An example is Bunker's painting, Tree, from 1884. It was carefully observed!

July 11, 1976, Sunday

I got up around 9:40AM and drove to the Clark Art Museum to again view the impeccable Bouguereau paintings. I studied the Sargent street scene and others by him. I also looked at the Gérôme masterpieces adjacent to *Nymphs and Satyr*.

Gammell's work has a very close resemblance to Gérôme. The general effect of Gammell's landscapes were very close to Gérôme's, outside of the impressionists' color of course.

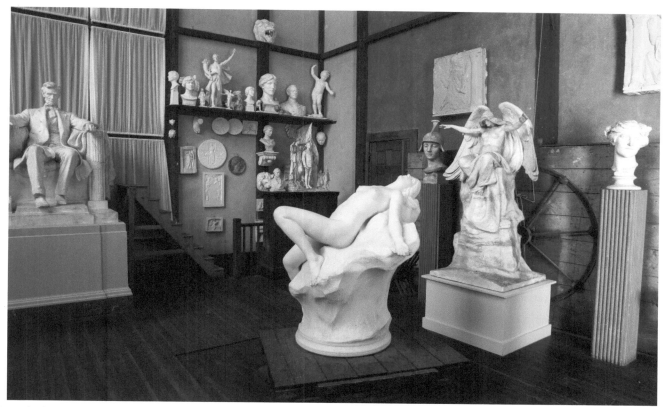

Daniel Chester French's studio, showing his *Andromeda* and his study for the *Lincoln Memorial*. Photograph courtesy of Don Freeman.
Daniel Chester French's Chesterwood studio, interior showing marble version of Andromeda, 1929-31.
Chesterwood, a Site of the National Trust for Historic Preservation, Stockbridge, Massachusetts.

As I left the Museum, I was giving a good deal of thought on how the conventions used by the academic painters were really very much based on the correct seeing of nature. The simplicity of areas in the background, with close observances of color notes and the overall effect of atmosphere.

Then I went to the studio where David and Jan were ready to make a trip with me to the Berkshires Museum in Pittsfield. We took Gammell's car and arrived at 11:45AM but the museum was not open until 2PM. While we waited we then decided to drive on to see the nearby Museum of the Sculptor Daniel Chester French, who did the Lincoln Memorial in Washington, D.C.

Viewing the work of Mr. French was stimulating, yet his monuments were not as impressive to me as the sculpture piece of a girl, nude and lying on a rock with hands chained. It was very refined and handsome above everything else.

French's studio was tall with light coming in from the top. He had railroad ties and a car as a platform to enable him to pull his pieces outside the studio for better light.

As we headed toward the Berkshire Museum we lunched at an outdoor cafe.

In the Berkshire Museum we saw one of Bouguereau's works. I was particularly interested in its subtle light on a peasant girl. She held a young lamb and looked down toward its mother. This canvas was more directly painted but was very typical of his excellence.

After arriving home, I saw Gammell out on his patio and went out to talk. He asked about what interested me and I told him. We then talked about Ingres, Stuart, Reynolds, and Lawrence.

He told me of Paxton's view of Bouguereau versus Sargent, which was interesting. Those artists seem to captivate painters, both with hostility and with great admiration. This proposes, at times, that Bouguereau was vulgar or sweet and Sargent a little too slap-dashy without real emotion. But their accomplishments were also greatly admired. So, doctors disagree?

July 12, 1976, Monday

Utilize White, Ochre, Indian Red, Light Red, (no Cadmium Scarlet) for flesh. Not enough glue in the priming causes the absorption (sinking-in).

Gammell was often dismayed at poor quality products. The aforementioned Vibert medium was an example. It was a recipe often used that is now lost to history.

Gammell worked again on my portrait. He stressed the importance of using a simple palette (colors). Once again, the drawing was the thing that was to be improved and made more 'like'. He mentioned how Whistler said, "You take a portrait, lose it in a fog, then bring it out slowly." Gammell said of Whistler, though not a strong draftsman, he had something of the right idea.

I worked on the entire portrait area to key it, and to keep it progressing as a unit.

Gammell took a pinkish note and scumbled over the mask of the head (in the light area). I thereafter pulled out some of the drawing of her features. At this point the portrait was really taking on form – yet without detail.

The afternoon visit with Gammell lasted only about 5 minutes because the day was too cool and rainy for landscape. Instead, I retouched the portrait and two landscapes which would help their surfaces a great deal by combating the absorption of paint.

Played chess with Dave and lost.

Late afternoon, about 3:30, I left for my landscape spot. I began painting and then rain advanced from afar and finally caught up to me.

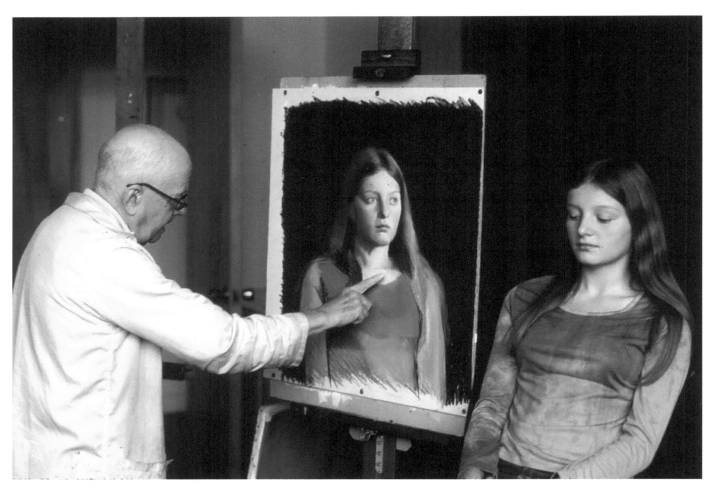

Mr. Gammell offering a critique.

Studio work was set up in a carefully orchestrated Sight-Size arrangement, as pictured here and on the preceding page.

This portrait was done in pastel, life size, directly from the model.

Achieving an accuracy of shapes was paramount. Any design elements in attire that might also help to explain the underlying anatomy, like folds and creases, were sought after. These would then be incorporated into the work in such a way that they contributed to the whole.

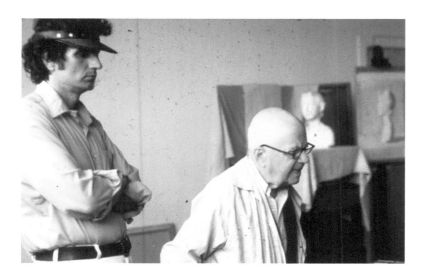

On the left is fellow student David Lowrey receiving instruction from Mr. Gammell. Gammell is standing back in a viewing position which allows him to view the ensemble (the work and model) in Sight-Size.

Lori, our model for the summer, posed for Dave and Jan Posvar in a separate studio. I was next door in the adjacent studio. Both studios adjoined Gammell's in the residential area. They were illuminated from the north, which provided a soft and cool note to our setups.

Afternoons were generally set aside for plein air work, except on rainy days during which times we would continue with personal artwork.

Gammell always maintained full control, but permitted individual preferences. He had a habit of injecting new words into our conversations, often with a dash of humor when doing so. He was regularly available to us and would check on our progress as each day passed.

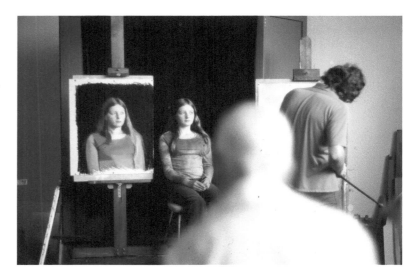

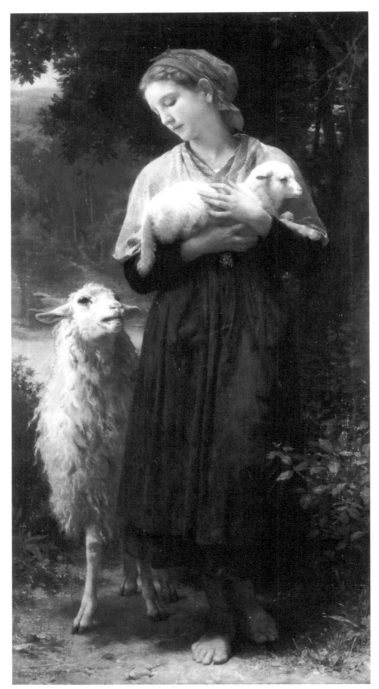

The Newborn Lamb, by William Bouguereau (1873), The Berkshire Museum, Pittsfield, Massachusetts.

July 13, 1976, Tuesday

I worked on a portrait of the girl, head and shoulders: Lori was my model. Primary scumbles: pink/white and yellow/white. Squinting to see the big note.

Gammell asked me if I was familiar with the Carolus-Duran story. I said some of them. He said, well this one was when Carolus was at a pupil's easel and put his hand out to the pupil (expecting to be handed the student's palette and brushes). Instead, the pupil took his hand and shook Mr Duran's hand, as if he was being complimented by the instructor.

Then Mr. Gammell removed his glove from his hand, extended it to me and said, "Well I wish to congratulate you on a very commendable job." This was in reference to the portrait on which I was painting. Having said that, he then gave me some suggestions concerning the blouse relationship. He quoted something – "the drawing is under there so do not hesitate to change what you have to, to make it better."

Today, Gammell talked to me about the people who tell or ask him where are the portrait painters who are high caliber. He looked at me and said, "There you go! It's yours if you want the opportunity."

He mentioned trying to prepare Gary for the job but he did not stay to pick up and follow through for it. He thought Gary may have been fearful to do something like that, who knows?

Shortly after the noon meeting, Gammell came into my studio to work on the portrait while the others watched. He was concerned in showing me how to leave the canvas surface – so as to have the ideal surface to work on when ready tomorrow. (Eliminate bumps, soften edges etc.)

July 14, 1976, Wednesday

Today, the early meeting was brief and Gammell said he would be in to see me as soon as the model came. Dave or Torn usually picked up Laurie and Andrew, who were our models as well as siblings.

He suggested I work on developing the drawing of the face and the modeling. He also said Paxton made use of watercolor touches 'to establish high lights' and generally to make changes where needed.

The phrase "watercolor touches" is not literal. It simply meant very delicate touches of a thin film of oil paint.

The afternoon meeting also was brief and I said I would be working on a landscape as the day was right for it, although it was quite cool out.

At 5:30PM I returned to clean up and played chess with David. We played badminton, then washed clothes at the studio and at 10:00PM headed home. I received letters from Steve Gjertson and Margaret.

July 15, 1976, Thursday

Meeting at 8:30AM.

Mr. Gammell said he would be in when the model arrives.

Gammell: Poppy oil is whiter, slower dryer and Linseed oil is more suitable. He put a little on the palette to use as a retouch for dark, sunken in areas. Applied with a sable brush. Linseed oil preferred. Avoid using too much, or better to not use at all!

Joseph DeCamp's law of color: You need not make the color as it looks if you know them (the tone is all important). Gammell says he has never found that statement to be accurate. Gammell differs here, stating that getting the tone and the color right to be very important.

Gammell lightened the blouse and went after putting the proper pink notes down on her face.

I listened to the democratic convention. It just happened to be on the news.

July 16, 1976, Friday

Morning meeting with Gammell.

At the meeting this morning, we check in the same as on previous days. As I and the fellows were leaving, Mr. Gammell asked me how old my daughter was. "3 ½ yrs. old," I said, and he asked if my wife will be coming. He seemed to indicate an interest overall in my future plans; background that was relative, etc.

He proceeded to talk about his book on 'drawing' which he is now writing. He was recalling his early training and the misuse of cast drawing, to finally not using them at all for a learning tool. The 1930's saw the so-called incompetent artists who managed to obtain key positions in various art schools and the very large number of students permitted to study at one time. Gammell says that this greatly contributed towards ruining the proper class structure.

His book dealt principally with David, Ingres, and Degas.

The use of practical painting and drawing is of importance when seen through an uncompromising eye that makes nature the more important element. He also confided that none of his pupils have become concerned enough to carry on his work. I was very moved by that revelation and stated that I intended to write and paint, teach, and keep an effective program for passing on all of this very important information.

The day before, Gammell also mentioned that he discourages those whose talent is not sufficient to continue in art. He feels the sooner they are aware of it the better so they can plan ahead, thus getting it out of their system.

On the portrait I was to develop, in a loose manner, the placement for the red and green flower print along the blouse. At all times, I was to keep the surface quite under control and apply the paint in an 'across-the-form' fashion to control ridges. Gammell also insists on good brushes to do the job.

His use of a few drops of linseed oil is a noticeable help in bringing out sunk-in areas and works very well to paint into. I am finding that turpentine alone and much thinking (painting of nature) goes along way. Then, if needed, some use of the linseed oil.

Following the afternoon meeting, I brought to Gammell a landscape of a long view of the countryside. He said he wouldn't dare (personally) to work on that large of a landscape, but that I may be a natural for it. He suggested working toward establishing a feeling of the levelness of the ground in order to stabilize the picture and to watch out and avoid sharp shoe lace lines on the contours. He said there are a lot of good things in it.

Over the past few days the burglar alarm system was put into operation and we heard the working of the siren, on and off, to test it.

Mr. Gammell and David stopped to see me under the bridge as I worked on the river picture. Gammell did not feel it safe to hurdle around the slippery rocks where I had set up. They returned to the studio and I went on painting until 6:30PM.

I returned and played chess with Dave and then went home. Had a beer and some Doritos.

July 17, 1976, Saturday

Gammell's first teacher was William C. Loring. Recommended by Tarbell and Benson. His second teacher was Sergeant Kendall.

He went to see Howard Cushing, who was recognized by (Tarbell and Benson) as the best student of Bunker. Unfortunately, he was not taking students at the time.

Kendall sent Gammell to DeCamp for help. DeCamp was painting Gov. Draper at the time. He told Gammell to go to the Boston Museum School and study under Hale.

Paxton had charge over the antique class while Gammell spent one year to see if he could be a painter.

Gammell went to Paris for 1 year before the war. He came back to Boston and found that all the teachers of the Boston Museum School had resigned.

Paxton substituted for Philip Hale's antique class and it was then that Gammell and Paxton got to talking.

Kendall, being Gammell's first real teacher, was one in whom he trusted and corresponded with at very regular intervals. That is, until Kendall wrote to Gammell saying he never wanted to see him again. This happened to involve a girl Gammell had seen on occasion. Kendall's rejection left Gammell uneasy and totally at a loss as to who he could turn to for help. Kendall later married Ms. Herter, his pupil.

As a matter of course, Gammell continued with the Hale class. Eventually it happened that Paxton replaced Hale. When Paxton spotted Gammell he said, "How are you coming with your work?" And so they began to talk a bit.

Once, when Gammell and Paxton were walking home together, Paxton said, "Whenever you need help on your work let me know." Gammell thought to himself that he would never do so because Paxton was not a pleasant manner of a man and Gammell did not feel he was a good painter. But Gammell eventually did go to Paxton, after having thought out his options. He now says that Paxton was the best teacher he could have had, and that he was someone who was the most artist-like in workmanship and attitude.

Arnold, by R. H. Ives Gammell, (1934), oil on canvas.

A still life, in progress, of student work. The setup is arranged in Sight-Size.

One day while Paxton and Gammell were chatting, Gammell thought he would mention to Paxton his wanting to do work like Mantegna the decorator. Paxton said Mantegna was one of those super human artists. That comment made Gammell much more comfortable in his relationship to Paxton.

At the afternoon meeting (1:45PM) Gammell asked us what we were all doing. It happened that we were all landscaping. When I told him I'd be at the top of a particular mountainside, he said, "Very good, I will accompany you and see what you're doing."

When I returned at 2:50PM, Mr. Gammell was sorting his papers for the book on drawing. He said, "Please sit down and don't utter a word until I've gotten these things in order." So I sat and he managed to get them together.

Because I was curious about how to properly begin an Interior painting, I asked how it was done. Before explaining precisely, he told me a story of when he told Paxton he was not going to do those 'Boston interiors' because he disliked them entirely. To which Paxton said, "Then that is exactly what you should do!" And he did just that for several years thereafter.

The idea is to work on your weak points (as in doing a picture to develop the furthest thing wrong, etc.) and therefore to learn a great deal more. Gammell now feels this advice was the best he could have received.

Paxton could evaluate a picture and one would immediately see that he knew what was in err. Gammell also mentioned that once Paxton entirely repainted a portrait he had begun and said, "Substituting for a better statement?"

Gammell proceeded to show how to set up an Interior for a painting. After his preliminary dialogue he got up and grabbed a folding 'outside' chair and placed it in a corner of the room. Then, with a foot on the chair, while being seated on a taller desk, he looked down at a notebook. He said, "Suppose you set up this area for me, in this

manner and using these items. The thing to do next would be to move things around until you've worked out the composition. Then, seated at the other end of the studio, pay close attention to the rectangle and work at it as you have the portrait" (establishing the big look first, etc.). He added, "The use of diagonals aids the movement when aligning objects in an interior scene."

Robert Lesley Hale's book, on Jan Vermeer of Delft: "It is poorly written but done with very good insight," states Gammell.

While at a landscape he mentioned the difference between that and interiors is: "The outside effect cannot be hit (achieved) with paint as they are, but in the studio it can be."

At the landscape itself Gammell said "Go after the brightness of nature in the largest, flattest notes, so that a close relationship of the whole may be quickly seen first!" He mentioned that of all painting the shadows were the most difficult to hit in color and value. Once these larger areas have been established, then one may carry further, always attempting to retain that large flatness. (Degas?)

What of Paxton's landscapes? "I think they are awful," said Gammell, "I do not like them at all."

July 18, 1976, Sunday

After a coffee and apple puff at Carrol's Restaurant I went to the Clark Museum to delight in the flatly painted areas. Those opened my eyes to new vistas of the proper technique of painting pictures.

Leaving the museum, I went to the studios and pondered what is an arabesque? And, is L'hermitte worthy of attention as a group (of figures together) designer?

So I went to Gammell, who sat reading the Times in his living room. He bid me to come in and I asked about L'hermitte first. To which he said, "He is a mediocre painter and not very original in concepts. He is in the shadows of Millet."

I then asked what is an arabesque? He said, "Now that is a very important thing altogether. I will have to get up for that and try to show you."

We went to the adjacent studios and he looked through the *Masters in Art* series, pulling out various artists including Turner, Rembrandt, Bastien-Lepage, and Monet. He said these men are all spotters to a superb degree, siting various examples.

Gammell then asked me who are the greatest of the masters. He often tested us with questions to check our knowledge. Answering for us, he said, "Considered so by most all artists, the seven: Leonardo, Michelangelo, Raphael, Titian, Rubens, Vermeer, Velazquez." "The eighth would be a very difficult one to choose from," he said, "possibly Veronese or Tiepolo."

"The *M. Bertin* painting by lngres is very well thought out, as to the rectangularity and variedness in its imposing silhouette." A masterpiece. Gammell stated that Ingres "could so design (his works) that would make any other painter's work seem as worms" by comparison.

"*Olympia* by Manet has the attractive variations of design and spotting that exhibits careful attention to outline (arabesques) as it goes along here, over bumps there, short lines followed by sweeping curves without any repetition or sameness to detract from it. It is a symphony of rhythm and balance."

"Puvis De Chavannes was sometimes oversimplifying, yet with that same careful attention to adjacent or intersecting lines of form and flatness." He utilized variation of design well suited to interior architecture for murals.

Recommended reading by Gammell:
- All Kenyon Cox's books on art.
- Philip Hale's books, especially *Vermeer*, but it is not well written as a literary piece.

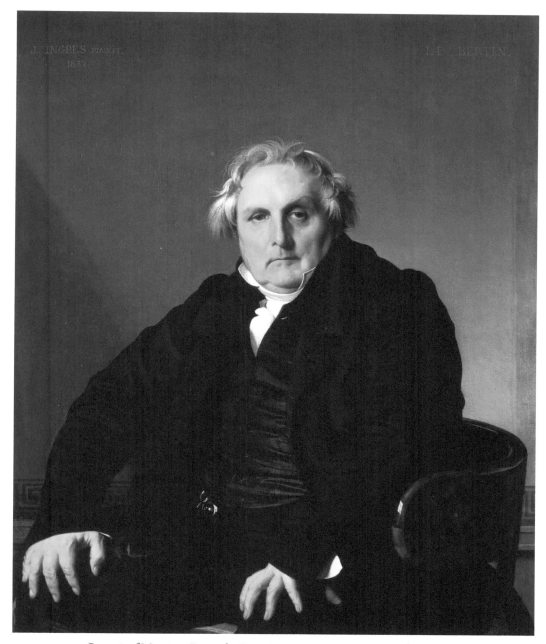

Portrait of Monsieur Bertin, by Jean-Auguste-Dominique Ingres (1832). The Louvre, Paris.

- *The Masters in Art* series.
- R.A.M. Stevenson on *Velasquez*.

Personal note: Sunday night my car was hit in the driveway and the door was dented by Mary Dempsey who let me know through her sister K. Lally. I went for an estimate on Monday at 11:30.

July 19, 1976, Monday

At 12 Noon I arrived at the studio. Tom was already there, working on a portrait. I waited for a call concerning the car estimate. I gave the go ahead to Archie's Auto Repair.

It was otherwise a very beautiful day. I read from Kenyon Cox and talked to Tom for a time on the general mood of painting today. He then went out to landscape paint and I resumed reading.

In 1895 Kenyon Cox published a poem, *The Gospel of Art*, that summarized his idealism about the artist's role in the mounting emotion through sacrifice and the function of one's art in the culture as follows:

Work thou for pleasure; paint or sing or carve
The thing thou lovest, though the body starve.
Who works for glory misses oft the goal;
Who works for money coins his very soul;
Work for the work's sake, then, and it may be
That these things shall be added unto thee.

 -From *Old Masters and New* by Kenyon Cox.

"Blashfield is another artist of very accomplished work."

Assistants of E. H. Blashfield:

A E. Foringer and Vincent Aderente. Not much is known about them today. They also worked together on mural designs (very good).

 C.Y. Turner did decorations in the Court House of Cleveland, Ohio.

 A R. Willett was another Blashfield assistant (mediocre).

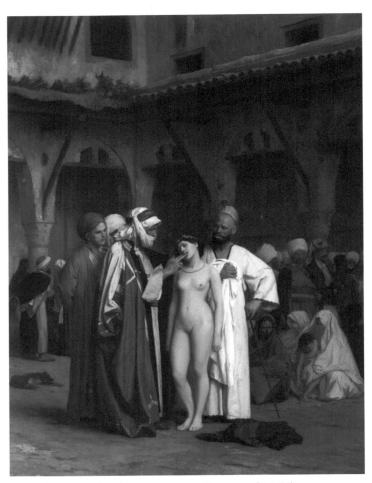

The Slave Market, by Jean-Léon Gérôme (1866).

July 20, 1976, Tuesday

I arrived at the studio at 9:30AM.

Tom was working and I was uncommitted as to what to do. So, at 10:00AM, I went off to the Clark Museum to take closer looks at Alfred Stevens and Henri-Joseph Harpignies' landscapes.

I returned to the studio around noon and worked on the drawing of Andrew, Tom's model, for half an hour.

Tom and Andrew went home at 12:45 so I looked to read something. I found a series of reproductions of Paxton. One painting in particular of real impact was of two models resting (nudes) – very good. The article stated that the judges were unwise to give awards out to bizarre pictures (Paxton's were much stronger than those by Leon Kroll, etc.).

At 2:30PM I began to work on the 'five finger exercises' outside near the driveway. I left the studio for home at 4:30PM. Tom locked up and also left.

I received my wife's note plus $30.00 (which was much needed). I cashed it at the cozy corner restaurant and had supper, which was a $3.94 spaghetti dinner. I then walked home and read. I also asked Bernie if he would pose for a portrait. He happily consented.

R. H. Ives Gammell in the studio.

Bernie was another boarder of Mrs Lally's. He was 80 years old and we became fast friends while I was there. He was my model for the rest of the summer. He also owned a shop for taxidermy work close by, which I later painted interior scenes of after my studio hours.

Notes on Painting at Williamstown.
Throughout the past few weeks, Mr. Gammell put special emphasis on particular areas of learning such as the constant care of the surface. All edges were to be kept under complete control without buildup. The edges would be repainted as sittings would require. Paint across the form, not along it.

Brushwork was not to get ahead at any time during the process of painting. Sargent was noted for scraping down to the bone after each session for that purpose.

Degas, Ingres, and Gérôme were always prominent in Gammell's words, and in his collaboration with Paxton.

Paxton used no medium except turpentine (rectified). Then, and only then at the finish, he might use poppy or linseed oil for darker areas.

Gammell considered and told me that Gérôme was the most knowledgeable artist of the 19th century. He mentioned Gérôme's painting, the *Slave Market* at the Clark Museum as his personal favorite.

July 21, 1976, Wednesday
The key to Puvis De Chavannes success as a decorator was first of all his 'light tonality' and harmony to the sandstone color of buildings. Also, his use of interesting and varied spaces – at times leaving them beautifully empty.

Puvis is not a painter that I had seriously considered important (previously). But Paxton's statements that certain desires in one direction are an indication that one should 'do the opposite' keeps haunting me and I find I now thirst

for those painters whom I have otherwise ignored or dismissed. If, for that reason, my seeing and talking to Gammell has hastened, then thanks be to God!

Over the past two days I've spent much of the time reading *Old Masters and New* by Kenyon Cox and *Mural Painting* by Edwin H. Blashfield. Those authors have helped me to see the err of my ways and point me toward a more productive and broad sense of artistry.

Always strive to retain the flat in painting.

The entire canvas must be blocked-in, in order to proceed further.

The background relationship must be true. Very important.

Ask Gammell: In figurative work, how should picture proceed tonally? Piecemeal? At any time piecemeal? As interiors with many items? Answer: a simple line drawing, as needed, then make it with paint.

Gérôme is said to have not drawn out everything beforehand but he began directly on the canvas. Yes or no?

July 22, 1976, Thursday

Tom picked me up this morning and then we got Andrew.

I worked on a pencil study of Andrew. It turned out well. Gammell later looked at the drawing and said to frame it and seemed to think good of it generally.

I worked the afternoon on a landscape near the driveway. Mr. Gammell brought the Bouguereau book for me as well as one of Ingres and Stevenson's *Velasquez*. He is permitting me to study the Ingres book in my room (he wrote it) dealing with his ideas on drawing etc.

Gammell had me heavily varnish the portrait for a workable surface to 'bring it out'. He also worked earlier on correcting my small landscape.

I picked up my car from the shop at 4:25PM (for repairs on the door and fender). I then went with David and Jan to see the movie *Richard III*.

We had no meetings today as Gammell, Jan and David got in from Boston at 11:45 AM. Friday will be back on schedule.

July 23, 1976, Friday

Received the books, *Ingres* by Amaury-Duval and *Velasquez* by Stevenson, from Mr. Gammell to read.

The discussion this morning was on the pictorial ideas of Carolus-Duran and his training of Sargent.

'Poppa' was a story of how Sargent could have painted such a good portrait of Carolus – and Carolus replied, "Because Poppa was there."

We talked of the coincidence that Gammell had lived in the same studio/apartment as Stevenson did in France. It was located just behind the entrance to Carolus-Duran's Atelier. Gammell said he would often hear of the goings on at that Atelier. Stevenson was studying the same time as Sargent.

Shortly after the morning talk, the models arrived. Gammell came in to see my portrait. He was relatively pleased at the ensemble. He had me supply a few drops of linseed oil on the palette to help the painting of the background which was dark. He said, "Now the idea is to continue to work after the furthest thing wrong and to more or less clean it up. Then, to keep on guard for those slight occurrences which may amuse you. (or have a pleasing look). Seize them!" In this case he spotted an interesting play on the chair-arm-sleeve area and took the opportunity to get it down because it was the most charming now than at any time prior.

As was his custom, Mr. Gammell would climb a small wooden box (which he called, 'the equalizer') to enable him to attain the proper height in order to view the motif from my eye level. He held my arm so as to balance himself and went ahead, very decided in manner as how to work out the following necessary changes.

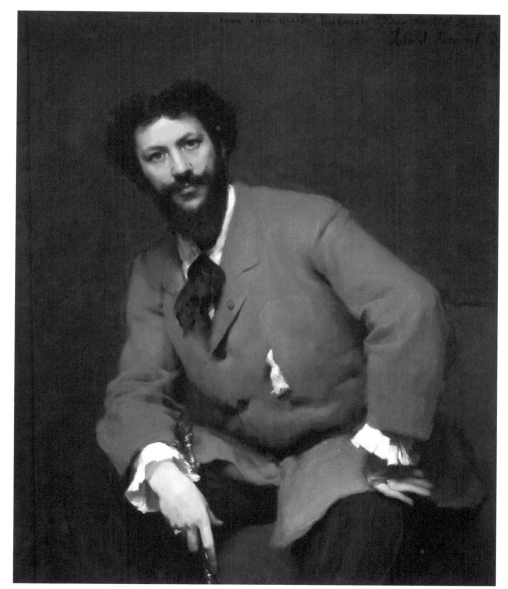

Portrait of Carolus-Duran, by John Singer Sargent (1879).

His ability (at age 83) to manipulate the brush, seize the right admixture of tone and color, and then to carefully make whatever change, was to me, most awesome.

He liked his students to stand directly behind him to see what his changes were, etc. His insistence on exactitude and the correct overall impression was absolute. However, he was always mindful of good design as the frame indicated. The only exception being out-of-door painting. For that the key should be as high as possible and then to work towards the proper tone relationship, from the sky to the darkest dark.

His popular phrase would be, "It's like stealing candy from a baby," which indicated how simple the adjustments were to be made at each sitting.

It was my personal experience that Mr. Gammell was very good humored. He was quite obviously a cultured man who realized the peculiarity artists all possess. He often joked subtly with the models. When a break was needed, Gammell often suggested they take a cigar break while he discussed the picture with us.

After a first visit at my personal studio room, he returned from the other studio. Peaking back into my studio doorway he said, "Well, have fun, I'm off!"

Mr. Gammell's box, the *Equalizer*.

The noon visit was again brief and I remarked how I very much like his new paintings (he recently hung earlier pictures of his imaginative work). He said they had been done before WWII. He mentioned his admiration for Lord Leighton, as I do also. He stated that Gérôme missed some of what Leighton was.

My feeling was that his work looked like a cross between Gérôme and Ingres and I told him this. He was modest and said, "You do me too great an honor." At that point he mentioned Leighton as a favorite though others often don't respond to him (Leighton).

Jan and I went to a near hillside and painted until Gammell arrived. He stopped by Jan first and then to my spot.

When he saw what I had started, he said, "You are having an off day in this one," stating that the drawing was not accurate enough. "The composition could be better and the color notes were not flat." We both smiled at it and he joked all the while he attempted to right it. I thoroughly enjoyed his critics, especially with his wry wit always plentiful.

Returning to the studio, I promptly lost two games of chess with David and poorly copied a Bouguereau drawing so that did me in for the day.

July 24, 1976, Saturday

The morning visit was interesting because Mr. Gammell and all of us there discussed Tom Mairs. I knew him better than the rest and Gammell asked me what was my opinion of him. I said that I liked Tom. (Gammell liked to know more of what former students were doing and took an interest in their progress.) The discussion went on because Gammell was curious. We also talked about Lack's atelier – how many students he had, the general workings, etc.

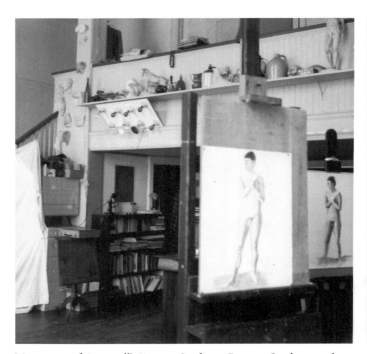

Two views of Gammell's Fenway Studio in Boston. Student work pictured.

July 25, 1976, Sunday

The bridge: I worked through the summer to help make small wooden foot bridges for Gammell on his acreage as he was a bird watcher and liked to walk the heavily treed area. I was ill prepared to fund my summer tutelage with him so he had a solution. He paid me to work on the foot bridges for him and I spent early afternoon working on it.

I was pretty much broke by that time so he stepped up after the guys mentioned my situation. That was nice of them and him.

David Moore was a young fellow I saw painting off to the side of the road. As I returned from the Berkshire Museum in Pittsfield he and I chatted for a short while.

When I arrived back I worked at the studio.

July 26, 1976, Monday

At the early meeting we discussed when the next model (Bernie, Mrs. Lally's other room boarder and next to me) should tentatively sit. The arrangement was 2 weeks from today.

Meanwhile back to the young Girl portrait: Mr. Gammell came to the studio to look at the portrait. We decided the back straggler was the blouse area. He then scumbled over the entire blouse with white and a trace of blue. It keyed up the blouse and helped to balance off the pinkish color it had been originally. He told me that at all times I was to be careful of edges and proceed to design areas as they might amuse the eye. The arms were the difficult areas to arrange attractively, due to the small canvas size for a bust portrait. The face and neck area needed some careful modeling with color nuances.

He returned again and only very briefly looked at it. He then asked me who the other fellow was that went to Europe with Childs and Tom Mairs. I said that it was Steve Gjertson and I wrote it on a piece of paper for him.

On the landscape Gammell said to push toward the relationships in drawing, key, tone, and color. He works very carefully to obey nature, because," there is nothing that can compose better than nature herself."

On varying days, when the landscape itself would change though basically be the same, he suggested changing it as it suits you. He said to always look for a more complete idea.

Strive for the big-look of nature.

July 27, 1976, Tuesday

I got to the studio and saw Gammell myself for a few minutes. The fellows had gone in earlier.

Gammell told me that Sargent mentioned his memory training experiences to DeCamp, and that DeCamp related them to him. It seems that Sargent's mother had John doing memory exercises from a very young age. The procedure was to 'take in' the images with the eyes and to then quickly shut them like a shutter of a camera. The memory of the images will increase as this technique is used more and more.

During the portrait session the concern was to begin to finish areas and to prepare the thing for finish. Gammell took a pinkish note for the arm and gently scumbled over it. He said to work over the area to secure the note and then the half-tone towards the shadow. This prepared the arm for the placement of the shadow itself – or the 'bed-bug line'.

While talking to Gammell this morning I noticed that he had a small pool of oil on his palette. It was curious to me that he utilized an oil for his very fine detailed work on such a small scale. I did not ask him about it, however.

July 28, 1976, Wednesday

A brief meeting at 8:30 then on to the morning portrait.

This morning the work was on the drawing and further preparing for finish. He went on to say that Paxton would actually paint the portrait in two days after a month's preparation.

While putting down some notes, he said you must understand that you want to go beyond the point of getting a likeness. It's about working toward combining all essential parts to a picture's frame. He added, "I think you will have a brilliant future ahead of you but do not settle for sufficient attitudes."

He said that his former pupil had recently thrown away a great deal for a moment's impulse in order to find an easier road.

To be fair, his student was thinking of marriage and felt somewhat trapped as to what to do. He chose to leave, which of course disappointed Gammell.

Gammell was enthusiastic about the portrait (more so than I) and wanted me above all to understand the working of the overall painting. He also added that his former pupil's portrait (which I never saw) was the best any of his pupil's had done with him. Interesting?

For the afternoon landscape session, Jan, Mr. Gammell and I went in my car to our usual spot. Gammell spent time putting down the relationships of two areas in order to help establish others. He said, "Ask yourself, 'Are the lights, light enough and the darks, dark enough?'" Also, "Keep the flat areas flat and the others as you see them."

While we painted, the field was being cut down in front of us. Mr. Galusha, who was cutting, stopped to visit Mr. Gammell as he was returning home. Afterward, Mr. Galusha talked to me and asked why Gammell had asked so much for his painting when he was generous in allowing people to paint on his property? I changed the subject.

Gammell later gave Mr. Galusha a painting free of charge. After I related the conversation to him, Gammell was miffed.

The fellows treated me to a movie, *My Tasty Frenchman*, which was about 1600's era Indian head hunters at the small local theatre, Bizarre.

Also, the employment office filed a claim for me yesterday. I'm down to 30 cents and no gas to run around on. Yep, poor as a church mouse but happy as a lark.

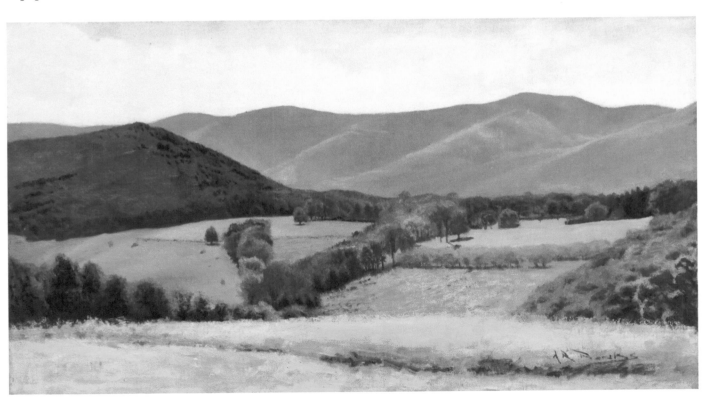

One of the landscapes I painted while under Mr. Gammell's tutelage.

July 29, 1976, Thursday

Worked again on the morning portrait.

At this point I was trying to put a completed look on it – designing sleeve-arm-chair and background within a small area. Gammell set it up to repaint it carefully so I could see the right way to go about it.

During the afternoon I used Lulu (the mannequin) as a stand-in to continue the arm work because the weather was wet all day.

"Mr. Gammell had a wonderful turn of the century mannequin that he referred to as Lulu. The real Lulu, Louise Heustis was a painter who studied with Hawthorne in Provincetown at the same time Mr. Gammell was there. They both happened to live at the same boarding house, which by the way had only one bathroom. Miss Heustis would commandeer the bathroom early every morning and occupy it for an inordinate amount of time. This drove Mr Gammell nuts hence he named his mannequin Lulu after Miss Heustis." -Tom Dunlay

Note to self: send work this fall to Allied Artists show at Grand Central Galleries, October, 1976.

July 30, 1976, Friday

After the morning meeting Gammell came in to see that I would work on the blouse area to begin finishing the portrait. The idea he wanted me to see was to use wet paint to secure a proper surface to work into – wet into wet.

The fine red trim along the neck area. He said that having the proper brushes was very important (which I didn't have) . He later gave me one of his brushes to keep.

He also scumbled on the general area of the blouse to work on it further. Of major concern was to leave no brush marks at the edges – rather to meet them, then gently sable them together as one surface. He said Gary was not one to enjoy working on clothing.

That afternoon I set up the Lulu to continue working on the blouse. The weather yesterday and today was not well suited for landscape.

When Gammell returned I asked him about Gérôme and Paxton. He said Gérôme could put a line down for drawing that could not be improved. Also, he could as easily put down the right spot in paint as well.

While studying in Gérôme's atelier in France, Paxton was sick for a time and took leave. When he returned and showed some canvases Gérôme said in front of the class, "You have unlearned all of your talent (or promise)."

Gammell said all Americans then going to France were doing so at a time when Impressionism, Realism (like Bastien-Lepage), and Classical painting were in the air. They wanted to try it all.

Gérôme's Medium:
1 part oil
1 part dammar varnish
1 part turpentine

To do:
Allied Artists of America, Inc. (Exhibit)
63rd Annual Exhibition Oct. 29- Nov 14 at the National Academy Gallery
Fee: $8.00 Commission 20%
Entry cards due and work due Oct. 14th

Write: New York, NY 10011, or (phone number omitted)

July 31, 1976, Saturday

Today Gammell said of himself that he was more of a designer than an impressionist, which I also feel comes through, particularly in his landscapes.

He is pushing me to utilize more of the design of the drapery and related areas than to leave it otherwise.

It is vital to get the clean note of nature in order to better the larger impression.

Gammell stated some time ago to steer away from using too much Crimson or Cadmium Scarlet, especially in flesh.

Burnt Sienna is also not recommended for flesh. However, Indian Red and Light Red are important as is Ochre. Gammell stated Ochre to be the artist's most valuable color besides white.

He was continuously dipping the brush into turps before pulling colors onto the palette for mixing.

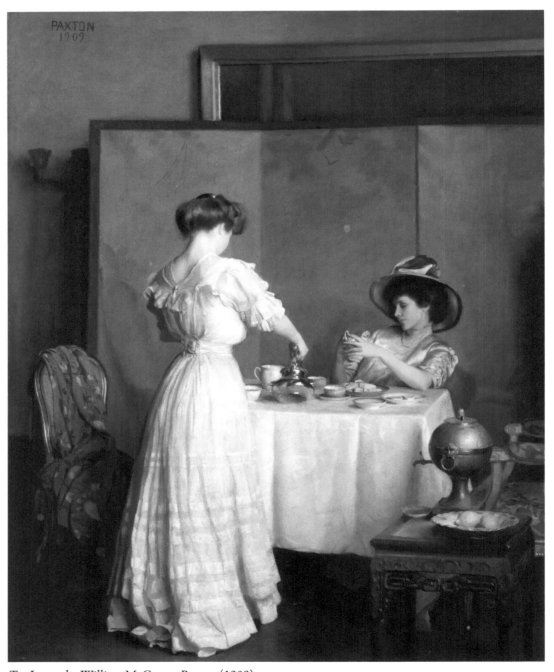

Tea Leaves, by William McGregor Paxton (1909).

From Seven To Seventy; Memories of a Painter and a Yankee, by Edward Simmons, 1922, pages 124-125.

I began to paint as soon as I joined Julian's. My first work was the head of an Italian; it was very bad. Boulanger stopped in back of me and said: "If you go on this way, you might as well go home and make shoes."

A thing like that had seldom happened to me; I couldn't help showing off, and it hit hard. I realized that the criticism was right, but I thought that he should have told me how to cure myself. So I left the room and waited on the stairs for a half hour before he came out. Seeing me, he tried to push by, but I stopped him, saying:

"I admit everything you said. I do not know anything, but I came here to learn. (By this time the tears were streaming down my cheeks.) You shall not leave here until you tell me what to do."

He thought for a moment. "Well, have you seen the outline drawings by Gérôme?"

I thought them the finest things I knew of, and said so.

"Go back and make one, and mind you, young man, see that you take a week over it. Good morning."

These drawings were larger than the academy paper, so I got a three-foot stretcher and put wrapping paper on it. They wouldn't let me in the front row at school because it was too large and obstructed everyone else's view; I had, therefore, to go in the back of the room and stand up to see the model. In two days I had finished it, and I started it over again, rubbing out so much that I wore holes in the paper. After one every week for three weeks, they came easier.

Boulanger was away on a vacation, and when he came back he passed me by as though I did not exist. July, August, September went by and still he ignored me. I was too scared and miserable to speak to him. Finally, one day he walked in back of my easel and halted as if shot! Turning to the whole school, he said:

"None of you could do a drawing like this, and I doubt if any one of you could copy it. " Then turning to me, "Let's see you make an academy."

I switched from being a loafer and chiquer from that moment, and realized that only by eight hours' daily work and hard digging could I become a painter. The next week there was a prize offered of a hundred francs for the best drawing – and I won it.

Scotland landscape by Frederic Leighton (1826–1903).

Gammell possessed a wealth of knowledge and his writings and books have added greatly to our understanding of those crucial periods just prior to and between the great wars. He witnessed firsthand the changes taking shape in the arts. Being a junior member of the group surrounding the Boston School, he and the students that entered his school preserved its teachings and philosophy. Due to that, we owe him a very great debt.

The painters coming to France from around the world had few choices for study but to seek out artists that would consent to teach from their studios. They might also have studied at the Académie Julian,* which was expressly set up as an alternative to the École des Beaux Arts which was extremely difficult to enter. The Julian Académie thus became the main venue to achieving mastery in painting or sculpture.

In general, the order for a beginning student was to train the eye. Cast drawing and painting delivered on that point from the very start and was practiced universally for generations. Drawing had to be mastered and the antique casts provided an added plus in understanding idealizations as created by previous masters. After a period lasting from a few months on up to a year the student went on to life drawing and painting. This was generally followed with portraiture and finally fully realized compositions.

The whole practice provided the firm foundation needed to permit growth

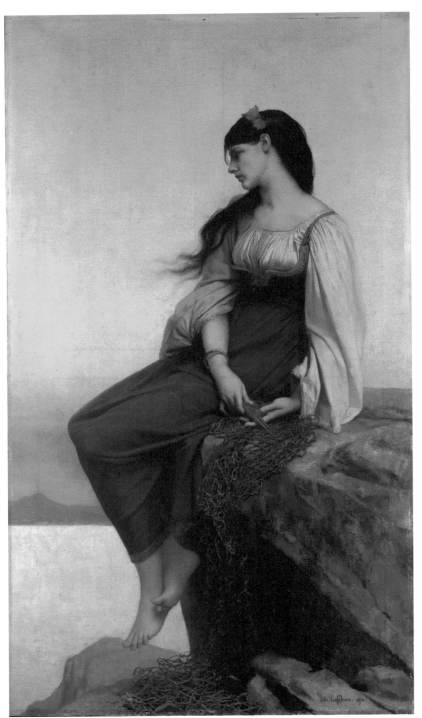

Graziella, by Jules-Joseph Lefebvre (1878).

into more personal work, which usually meant copying from the Masters, particularly artists that suited personal preferences.

Once the fundamental principals were sufficiently mastered the artist would eventually open a studio and then work to gain acceptance from a buying public through exhibiting, as Sir Alfred James Munnings (1878-1959) would later write about.

* Julian's Académie was the first to include women's classes and it eventually mixed genders together.

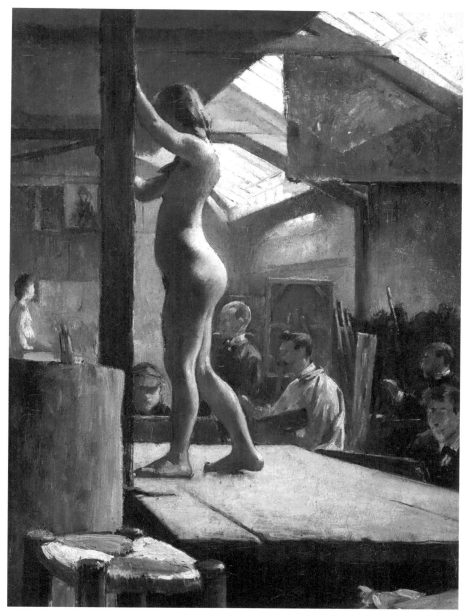

Life Class, Académie Julian, by Walter Herbert Withers (1887-1888).

Just prior to the first world war, Paris still presided over the world for all things art. The studios were everywhere and the Académie Julian (shown here) was still the best place to study for anyone looking for a way up the latter as an artist. Famous studios of artists like Carolus-Duran, Lefebvre, Bouguereau and so many others were available for visitors or they would see their chosen mentor at the Académie Julian. The Académie was founded in Paris in 1868 by the artist Rodolphe Julian (1839-1907) and became the alternative to the prestigious École des Beaux Arts.

Gammell was so impressed with the Paris art scene before the war he would later say, "The art world (of Paris) was so rich it could give one a kind of cultural indigestion," there was so much.

Carolus Duran stated, "When you can paint and draw the human figure, you can everything else. I paint these flowers to rest myself from the more difficult task of a portrait or a nude study. Everything is easier than the portrait or the nude." Later in the same interview the reporter further quotes Carolus, "I have only paid two visits to America, and I am not certain I shall ever return, but don't forget to tell the readers of The New York Times that I have a great admiration for the art movement in the United States. There is Sargent, for instance, who was my pupil, remember to mention that." From the New York Times, March 1900.

Gammell worked at the Académie Julian during the winter of 1913-1914. The teachers at that time were much inferior to the earlier artists of the 1880s, who had been under the tutelage of Lefebvre and Boulanger. They were the favorites of the Americans who had come to study.

That said, DeCamp was there and he was a frequent companion to the young Gammell. They often visited the Louvre, talking shop and making observations on certain paintings.

William Paxton similarly related to Gammell that the École des Beaux Arts in Gérôme's classes had fewer students, was less rowdy and was preferred to the overcrowded noisy and 'stinky sweet-smelling' Julian's of Gammell's time. Gérôme was painstaking in his work devoted to helping his students. He divided his classes into two basic study groups: one for classical and the other for contemporary interests.

Much of Gammell's story in detail can be found in his book, *The Boston Painters 1900- 1930*. As his student during the summer of 1976, I read many of the transcripts he was working on and was relentless in knocking at his door to ask for more of what he expressed in his transcripts.

To be able to listen to Gammell first hand was the ultimate treat for any of the students. All held him in the highest regard and hung on every word he spoke. He did not, however, suffer fool's questions nor tolerate slackness in moving ahead in a picture. "Never go backwards," was a saying of his that was always in my ears. I relished that phrase as a motivation to go for the Big Brass ring, which would be a compliment we all looked forward to if the job at hand was well done.

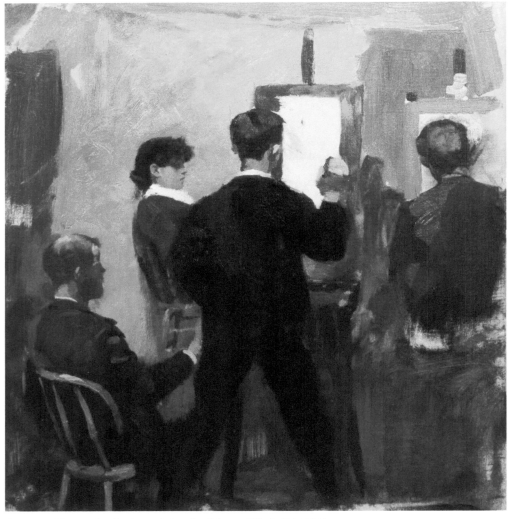

Painting Class at the Académie Julian, by Edmund Tarbell (*1883*).

Carolus-Duran teaching a class in New York City.

Carolus-Duran posing in his Paris studio.

Carolus-Duran's Mode of Teaching. The method of instruction pursued in the atelier of Carolus-Duran is described as follows, by one of his pupils, in John Collier's *Manual of Oil Painting*, (1886).

"The model was posed on Monday, always in full light, without shadow effect, and against a strongly colored background, which we had to imitate exactly in its relation to the figure. The figure was drawn in charcoal, then we were allowed to take a sable and strengthen the outline with some dark color mixed with turpentine, but not to make any preparation, nor put in conventional brown shadows. The palette was set as follows:
Black, verte émeraude, raw umber, cobalt, lacquer ordinaire, brun rouge or light red, yellow ochre, and white (the colours being placed on the palette in this order from left to right). We were supposed to mix two or three gradations of yellow ochre with white, two of light red with white, two of cobalt with white, and also of black and raw umber to facilitate the choice of tones. We were not allowed any small brushes, at any rate for a long time – many months or years.

On Tuesday Duran came to criticize and correct the drawing, or the laying in of the painting if it was sufficiently advanced. We blocked in the curtain first, and then put in the figure or face in big touches like a coarse wooden head hewn with a hatchet; in fact, in a big mosaic, not bothering to soften things down, but to get the right amount of light and the proper color, attending first to the highest light. The hair, etc., was not smoothed into the flesh at first, but just pasted on in the right tone like a coarse wig; then other touches were placed on the junctions of the big mosaic touches, to model them and make the flesh more supple. Of course, these touches were a gradation between the touches they modelled. All was solid, and there were no gradations by brushing the stuff of the lights gently into the darks or vice versa; because Duran wished us to actually make and match each bit of the tone of the surface.

He came again on Friday to criticize, and on that day we finished off."

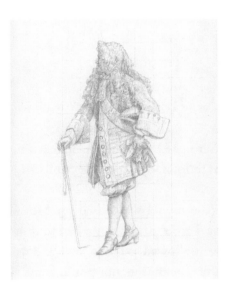

Above: Gérôme's portrait of Bashi Bazouk.

Gérôme's workmanship is above reproach with attention to every aspect of good design, careful characterization of subject and naturalness of gesture, no easy feat. Gammell always held Gérôme's canvases with utmost respect.

Williamstown, Massachusetts
August, 1976

August 6, 1976, Friday

Today, Gammell presented me with $150.00 for the bridge and others to be built. I was very happy because it marked the way to finish out the summer. He mentioned that a fellow will be coming in to show us all a Bunker painting, which should be on Saturday.

My portrait concludes this morning. It went well, though I feel it suffered by a lack of animation. I felt the model was unwilling help.

This afternoon I landscaped at the bridge.

I went to the movies at 7:00 PM with Jan and Dave. We saw *Omen*. Poor picture.

I talked with Miss Lally when I arrived home, until 2:00AM, concerning student activities and related things. I paid her $30.00 which paid me up to August 14th.

August 7, 1976, Saturday

Today I spent the morning working over some areas of the blouse and face on the portrait.

I now feel that to start a portrait the edges should be a soft blur and thin enough to allow much going over in paint. Gammell's continuous preaching on their control will stay with me, hopefully. But the portrait is done, albeit not complete as a portrait or a painting, though the lessons were and are there.

Later in the afternoon I fussed some on the landscape indoors, edges etc., since the weather was drizzly.

The major thing of the day was seeing the Dennis Bunker picture which was brought by two men inquiring of Gammell as to its authenticity. Gammell was very excited about its size and accomplishment. It was one of a hazy day, field and stream, painted richly and subtlety. I took some slides. The picture had a large rip in the lower third but it was 'clean' as Gammell described it. Gammell estimated the worth at $35,000. They thought $12,000 because Ted Volsum had seen it earlier and roughed a guess.

Later in the evening I returned home and talked with Bernie. We went to see his shop earlier, but he was at lunch. He's a taxidermist. We talked of an exchange – a picture for an animal.

August 8, 1976, Sunday

My wife and daughter arrive from Ohio for a brief visit at 6:00PM

August 9, 1976, Monday

Took off the morning and afternoon to wash clothes. The weather was very bad due to Hurricane Belle which had moved northward along New England's coast.

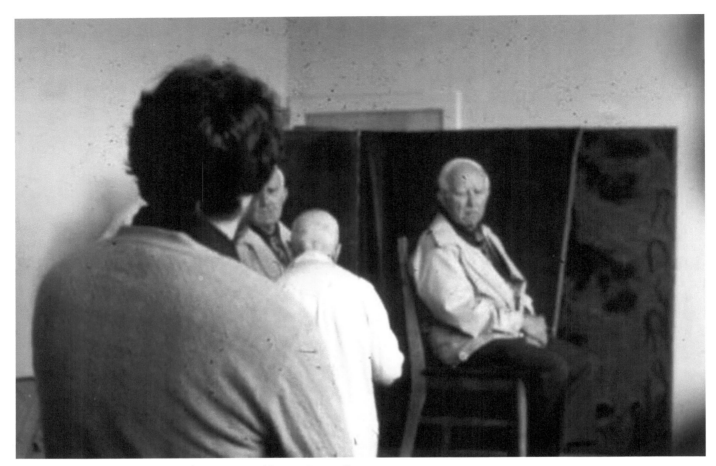

My painting of *Bernie*, in progress, being critiqued by Mr. Gammell.

August 10, 1976, Tuesday

Began a drawing of Bernie Lamoureux, (82 yrs. Old). I feel this portrait will have much to it. Gammell stressed not overworking the face to the jacket and chair areas. Began with a large brown drawing paper that will help put it together as a composition.

August 11, 1976, Wednesday

In reference to pupils, a good student can get on very well, learn all that is necessary, and yet never do better than a student when all is learnt (no further growth professionally). One must look ahead and grow professionally, very important.

I never felt comfortable being a pupil and did not do well (am very headstrong to move forward so must slow it down a bit), but my endurance and artistry is more earnest. My one track mind is often my biggest problem. I'm writing this in reference to Gammell's remarks regarding me not having put it all together (regarding Paxton's work).

He suggests at the same time that the portrait field is very open. I had a lack of appreciation for portraits by Paxton that changed as I worked with Gammell.

At times, I felt his observations on pupils were imprecise. As with putting (names omitted) into roles that I do not see them fit into at all. (Pigeonholing artists, as it were, into a category.) Although very few students ever actually realize a career at it.

The afternoon was spent landscaping on Galusha's land. (Property owner) His neighbor.

August 16, 1976, Monday

Gammell left Monday morning before Bernie and I arrived. We worked from 9:15 till noon. We then went to Bernie's place where I started an interior painting of the taxidermy shop.

August 17, 1976, Tuesday

We arrived early 8:30 working till 11:00.

I cleaned up, then Bernie and I went to Bruce's Taxidermy studio near New Lebanon. On the way back we stopped at Mrs. V. Jonas, widow of the late Louis Paul Jonas, the original taxidermy master. She happens to be an amateur artist and she told me of a Mrs. Betty Warren who works at Malden Bridge, Mass. So we left to go see this studio. We found it and it seems to be a loosely run colony. It has a nice atmosphere, but the instructor visits just twice a week.

Her Class fees:

Full time - everyday	Part time (morning or afternoon)
2 weeks - $150.00	2 weeks - $180.00
4 weeks - $250.00	4 weeks - $150.00
6 weeks - $325.00	6 weeks - $200.00

The impression I have is that New York and Florida may be very helpful to me in starting to build a powerful base artistically – particularly for prizes and art clubs who may help support my plans.

My hope is to grow artistically – to work incessantly – and to inspire others in some way.

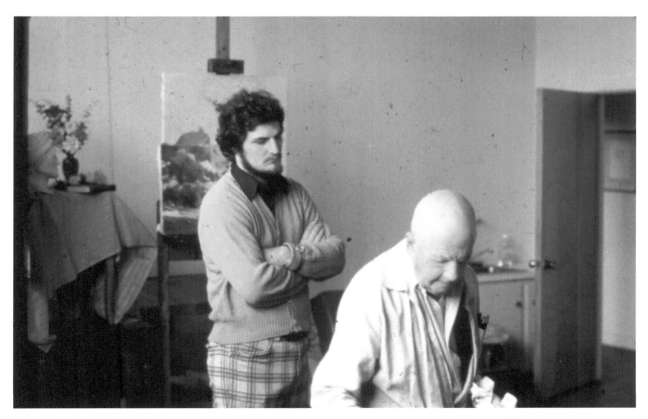

Mr. Gammell, critiquing my painting.

Bernie, by Allan R. Banks (1976).

August 18, 1976, Wednesday

I developed the portrait, working on the surface and attempting to paint as Gammell has demonstrated. He will be in on Thursday but will see it on Friday. I also made the bridge for Gammell, near front of his property. He was good humored about it.

I worked on the Interior of the Taxidermy shop. (Bernie's place)

August 19, 1976, Thursday

Worked the morning on the portrait and Gammell arrived at 11:30AM with Jan and Dave.

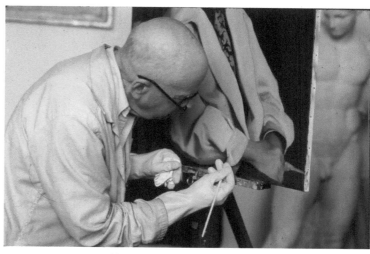

Mr. Gammell demonstrating a passage on my painting of *Bernie*.

Bernie and I were leaving and Gammell peaked out his window and said, "How's the portrait going?" Bernie said, "It looks just like me!" To which Gammell replied, "It should!"

After lunch time I returned and took Gammell and Jan to Galusha's land for a landscape session. He looked at mine and gave me some pointers, then he went to see Jan as I painted. I could hear Gammell speaking at the top of his shrill voice, but could not quite understand what all the discussion was about.

After Gammell had left, Jan began to put all his equipment together even though it was still early. Jan then came near to my spot and said he was quitting for today. Evidently Gammell had emphatically told Jan not to work on landscapes of such largeness and to return to doing small pencil sketches and oil studies, always searching for large relationships. I attempted to reason with him because I could see he was very discouraged. Jan appeared talented and industrious, but Gammell is very domineering and temperamental.

When Gammell sees the least thing out of keeping he might explode with stark criticism for such complacency.

August 20, 1976, Friday

Tarbell said, "I hate a picture that shows no sign of struggle."

Gammell said that was important. He also cited the contrast between the Tarbell-Benson ideal of painting and the academic – as illustrated in the statement below.

Gammell said that they (Tarbell and Benson) hated the superficial look of Bouguereau and Gérôme, and felt the struggle to portray nature was not there.

With exclamations, as "smash of light", or "getting it more like", impressionism became stronger both in practice and rhetoric as opposed to academic painting which dominated the French art world.

By this Gammell did not mean French Impressionism. Rather, he meant impressionism as explained in R.A.M. Stevenson's 'Velasquez'. This view was held by the Boston School painters, and was similar to Vermeer's.

Later, I brought an interior to Gammell. He said, "Well, it had some very good things and some very poor things in it. The color is too strong, the drawing is not entirely accurate and the idea of constant changing should be the attitude." The picture was painted twice (2 days work) and much improved later today.

His criticism was to always look for being better than just being good. "To be good is not good enough." He talked of Lack being too isolated and not surrounding himself with good people. Gammell feels Lack had an anti-Boston sentiment, particularly when he studied with him. He said yesterday that when Lack entered the service he wrote him every week for the entire time he was there.

Dream of the Shulamite, by R. H. Ives Gammell (1934).

August 21, 1976, Saturday

I worked this morning on Bernie then on a landscape.

August 23, 1976, Monday

Gammell was in and I worked on the portrait. I made changes to the clothing. He suggested that I try using pastel, or doing a fine 'lngres' drawing to help work out the drapery design. Drawing out the design separately saved overworking the final picture to solve issues.

"Sargent," he said, "could make clothing look 'Bingo, Bingo' – dashing it off as if painted in one shot. But that could not be the case", he added.

Paxton had a tendency to cheapen portraits of beautiful women because of his own peculiar personality. However, he was capable of a most competent execution.

Otto Grundman taught Tarbell and Benson.

Ask Gammell about the use of other media (pastel, pencil drawings) in resolving portrait issues. Also ask about the matter of taste.

August 24, 1976, Tuesday

Wet paint, 'for painting into', is something Paxton did. However, did Gérôme and Sargent?

Gammell scumbled out the portrait to simplify the overall modeling of the face. He used a fleshy red tint. Working over a dry surface, not oiling out but use pigment to paint into.

The shadow area was also worked into wet.

He all but said to keep ridges in non-edge areas. In other words, keep the ridges of paint within the thing being painted, but not edges on the contours (if there are paint globs). As Velazquez demonstrated, by softening the contours.

I worked on a landscape in the afternoon. Gammell came along.

August 25, 1976, Wednesday

"Paxton would sometimes take liberty at Sight-Size," says Gammell, "but I make sure all is very exact."

Did DeCamp?

He said DeCamp would at times change the color of a value if he felt it didn't suit him. Gammell does not go for that attitude, however, he insisted on the right color and tone straight off.

August 26, 1976, Thursday

This morning, when Gammell came in to get me, I had started on the portrait. He said to varnish out the head. I grabbed the atomizer and varnish and was about to blow it on when he exclaimed, "Don't use that thing! Brush it on!" The fellows all have been using the atomizer and I felt it was by Gammell's order, but that wasn't the case. So I retouched it with a brush.

Looking at the head, he then said it was advanced more than other areas, so work on the collar and lapel to make it final. As was his custom, he took a brush in his hand, with me directly behind him looking over top, and would start to walk up to the picture and place a note down. He would look for an amusing area and draw it as nature provides.

Study for Intruders, by R. H. Ives Gammell (1973).

He stressed that I should be constantly aware of new things, "accidents of nature", that might add to the portrait. He often mentioned that this particular jacket was ever striking, suggesting that it had an Ajax look. (Ajax was a Trojan hero.)

Later in the morning he would add a color note that was somewhat yellowish ochre and said, "Your note is not the right color."

"Sometimes DeCamp would change a color slightly to his personal liking," said Gammell, "but would defend his doing so by exclaiming, 'If you know the law of color relationships as light envelopes it only!'" Or, replacing a color over the actual tone,. Sargent threw a rose-colored glaze over the background of *Madam X*, at the Met, to replace the grayish note. The tone remains the same however.

DeCamp is said to have used oil and turpentine where Duveneck used oil varnish as a medium.

Lefebvre and Dannat taught Benson and Tarbell at the Academy Julian.

DeCamp also utilized Sight-Size according to Gammell.

The chief reason for the change from the academies and their formulas over to nature and impressionism was the bland look of their pictures. Fresh color was a pleasant break from otherwise being tied down as formulas tend to dictate.

Still Life, by Tom Dunlay (1976). Tom was working on this painting at the same time I entered Gammell's Williamstown studio. It is a fine example of thoughtful design , rich coloring, and careful drawing.

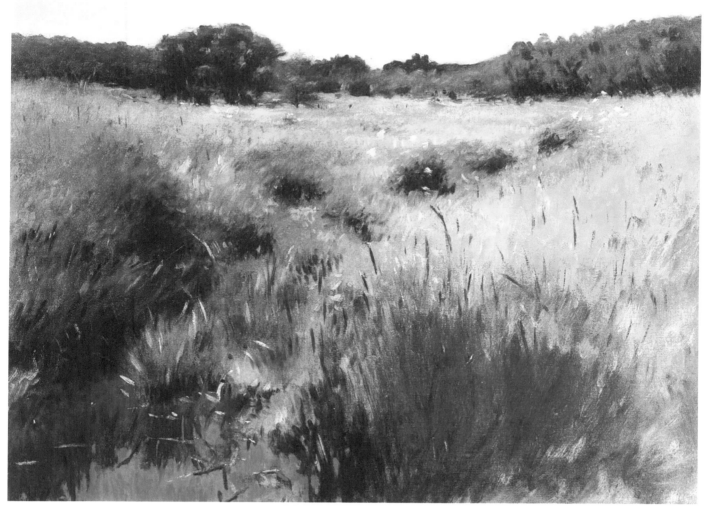

Marshland, Medfield, by Dennis Miller Bunker. Mr. Gammell was asked if this painting was indeed by Bunker. It is.

Notes on Painting:

- Arrive at the large flatness of relationships as they exist in nature.
- Careful drawing of all shape masses with charcoal or pencil precedes all painting.
- Key the picture correctly from the first. This is extremely important!
- Use turpentine only to stain in areas. Retouch generally before each painting.
- Oil may be used to finish or to help sunk-in areas. Most importantly is that the picture is seen clearly.
- In landscape, each area should develop from the furthest back straggler.
- Foliage is best done toward the end.
- Paint wet into wet.
- For portraits that need much work on the drapery folds, etc., use pastel or pencil drawings as studies to facilitate painting. This helps to avoid too much overpainting and correcting.
- A good painting may require many, many paintings (underpaintings) to arrive at the result being sought for.
- Keep preparing until finished.
- Classical painting is done by coloring in a prepared drawing.
- Design – diagonals are important to pictures.
- All edges must be painted with great care and melt with the surrounding areas.

Impressionism constantly corrects drawing because it helps one to follow nature's lead to redesign as needed. It also helps one to get the Big Look, and correct the overall drawing.

August 27, 1976, Friday

Does Kerry Holsapple have my palette?

Gammell answered my question on the uses of diagonals in pictures by showing reproductions of Holbein portraits. The objects surrounding the head gives the picture plane proper balance through the diagonal line-up of items.

This morning I read Kerry's letter, as Gammell asked, and he wanted my thoughts on it. Afterward I said Kerry was a nice fellow and possibly a good potential candidate to study with (Gammell).

Gammell then talked of his book on the Boston Painters and the health problems of the publisher

August 28, 1976, Saturday

Impressionistic perspective?

The difference between the academic approach and the more alla prima type for one's progress. Both are worthy to explore.

Angular lines are very important in strengthening shapes and avoiding the wavy 'shoestring look'.

Gammell was very fond of Monet and Degas but also wanted to work in a similar fashion to Frederic Leighton. (Which we both have in common.)

Gammell mentioned:

A. Pool – a student of DeCamp. Unknown today.

Jacob Binder (studied with DeCamp and Sargent). His peculiar traits: High minded, very serious, no humor.

Bosley?

This morning Gammell told me to carefully draw and 'make' the sleeve as it appears on Lulu. He insisted on drawing all the areas that 'tell a story' and to then paint to conceal the edges. Also, make allowance for any anatomical expressions that give clues to the arm in the sleeve, for example.

One point he emphatically stressed is the workmanship 'way' all painting must exhibit.

Look at the background when painting the head – and vice versa. He said, "Sergeant Kendall would stress this."

Also, in reference to the white jacket, he said pick up an expressive line (like the lapel) to make an attractive and varied a design as nature suggests.

During the noon break, I went in to see Gammell in reference to Kendall. He said "Yes, that's important. See me this afternoon to discuss it." I did as he suggested and he sat and talked at great length about the man Sergeant Kendall.

3:00PM Friday meeting

He said Kendall was a very serious and sober, no humor type of fellow.

When a young man Gammell wished to study with him and thus approached him accordingly. Kendall declined to take him on, stating that he was no longer teaching. Nonetheless, he made regular time each week for Gammell. They would meet on Fridays at 3:00PM. Gammell says he will always be grateful for having known him and learned a very great deal.

Kendall was a member of the National Academy in its heyday. The constant comment about him from other painters was that Kendall was a man of integrity.

After some time of regular visits, a year before the war, Gammell left for France.

During WWI Gammell saw Joseph DeCamp in Paris. DeCamp was there to execute a large and complex painting. Gammell introduced DeCamp to differing locals. They often went to museums for chats about pictures but at no time was it ever as peers, due to DeCamp's stature as a painter and Gammell was only a beginner.

While there, Gammell had a set of acquaintances and a girl, Christine Herter, who was also a pupil of Kendall. She was 3 years older than Gammell. Throughout their stay Gammell saw her a few times and took her to the opera at one point.

When the war started in July 1914 in France, they made haste to go home. He was abroad with his mother and brother. At about this time, Gammell wrote to Paxton to see if he would find a studio for him when he returned.

When home, Gammell went to visit Kendall again and at that time he requested to have lunch with him.

Prior to the sojourn, Christine Herter was taking lessons privately from Kendall, in a separate room with an attendant. All of this led up to Gammell's excommunication from Kendall, who later married Miss Herter after dissolving his former marriage. This subtle arrangement would find Gammell receiving a letter to the effect that Kendall did not wish to see him again! Gammell was crushed over the affair because he was unaware of Kendall's infatuation with the girl.

At the time he received this letter, he went to Paxton. Paxton thought it strange, but offered Gammell a chance to study with him.

Kendall was not a composer of pictures and could be very ruthless in manner toward students. At one time Kendall walked into a class, approached a student and picked up his canvas. He then smashed it over a chair without explanation. Sargent had the same thing happen to him when under Carolus-Duran. (I can't verify this statement about Sargent.)

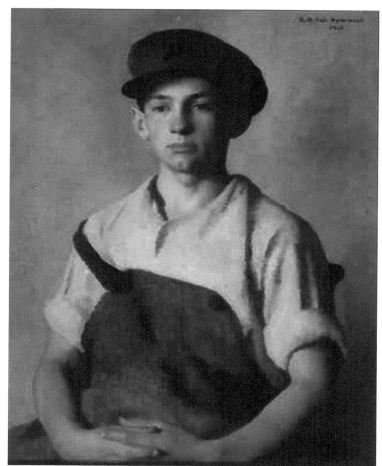

The Gammell portrait (shown on the right) is part of Provincetown's art collection: "William," a large oil portrait of the young boy William Cabral, later the town's postmaster, hangs in the Assessor's Office of Town Hall.
-From a 2001 News article report

Portrait of William, by R. H. Ives Gammell.

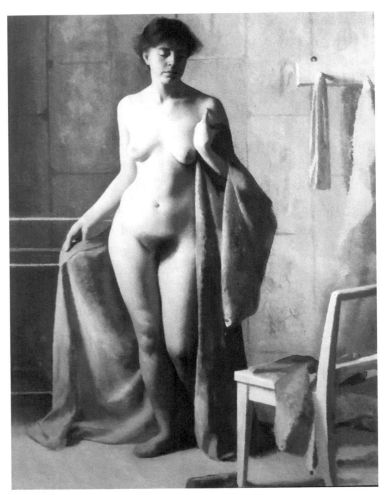

Nude Figure, by R. H. Ives Gammell.

Gammell cited a very humorous example of Kendall's manner. "Oh he was a horse's ass, a perfect ass," he exclaimed.

He told me that while visiting Kendall one day, Kendall's first wife, (who was also very sober) walked into the room and did some flower placing or some such thing. Gammell stood as she walked in. Well it happened a second time and he stood once again. The third time, however, he remained seated because he thought that she had nodded to remain seated. Noticing that Gammell sat, Kendall then immediately stood up straight! This made Gammell feel very foolish. He said this was a reoccurring type of incident of Kendall's.

Kendall had a peculiar habit of 'knotting a pose'. He did not really search for any feeling or gesture.

Paxton was very definite about looking for the 'gesture' in nature, as in Rembrandt's woman cutting her nails at the Met in NYC.

Gammell said a painter generally picks up the weakness of his teachers (along with the merits).

He also said he has had a stiff feeling to his own work as he looked over at some of them on the studio wall.

Kendall had many colors squeezed out while painting. Conversely, Paxton said the simpler the palette the better and used only seven.

In the chapter about Thomas Couture (French history painter and teacher), from the book *Traditional Painting 1848-1900*, regarding his painting of the *Age of Decadence*, (painted in 1847), he describes his method as carefully transferring the drawing to canvas with charcoal – tapping it as a drum to shake off loose particles. Then, using earth brown to form a bistre and to lay in the tonal areas of light and shade. He made sure that the brightest light was in middle area of the canvas and that it graduated as it neared the edges of the picture plane. This bistre was allowed to dry, then painted over to hit the notes as seen.

August 29, 1976, Sunday

I had Gammell look at the portrait of Bernie this afternoon, to check the jacket in its developing stages. He again reiterated the use of looking for color in shadows by not looking directly at the shadow.

Also, he related how proud he was of Richard Lack's portraits of his family. In particular two, one of which was a group of Mrs. Lack and their children. He said Lack did not sell it but should have, asking perhaps $25,000.00 for it. It would have stopped many to take a second look at it!

I expressed my admiration for the salon artists such as Bouguereau, Gérôme, Dagnan-Bouveret, and Regnault, as well as my respect for impressionist ideals. Gammell said that he too had inhibitions of the Boston school as he was interested in imaginative painting.

Regarding Gammell, Paxton said, "I feel like a hen with a duck." He also said that he had hoped Gammell would pass on his teaching of impressionism. Impressionist and classical ideals are not in conflict, but emphasize different points.

He added that the key to impressionism is the bigness of seeing. He recommended, as Paxton did, to pursue 'your interests' and develop a deeper understanding of impressionism. Bouguereau doesn't offer much in that direction, Gammell stressed.

It is my understanding, looking at the pictures by former students (Gammell students), that it is not simply a richness in color but tone relationships built up correctly, first with no reference at all to details, as such, but like a unified grouping of trees or rocks. Strictly a 'matter of fact' build-up, later developing into a well 'seen' picture. Details are then added.

Book – *Realism and Tradition in Art 1848-1900* by Linda Nochlin, Prentice-Hall.

August 30, 1976, Monday

Ask Gammell about what formula he found most useful?

Classical American article by Gammell on the Sargent Murals to be published!

Gammell's friend drawn by Sargent Charcoal $500.00.

No need for formula work as nature in its infinite variety suggests how to proceed.

Dancing Group, by R. H. Ives Gammell.

Gary called me, person-to-person, through Gammell's phone. Gammell said, "What nerve!" Gary asked how I was doing, then wondered if I could pick up his pictures in Boston? He said he was married now and planning to go to Europe for 6 months to copy. He asked if I would go on with Gammell. I said no, just this summer. He also wondered how I liked it? I said very much.

As a question to look for several possibilities in painting, I asked Gammell about the use of formula painting:

He said in decorative mural work, he kept a jar of flesh tone mixed for the lights, one for shadow notes and one for transitional color. These were used to keep all the flesh the same color and better for the unity of the mural. The jars were kept wet by pouring some water over the top to keep air out and the paint tints fresh.

While working toward the finish by 'Bunkering', or making it better, Gammell said that Paxton, after laying a portrait in with turps, would repaint the top of the head to halfway down, say to mid-nose, then work the lower half during the following session. This was in the later stages of the painting. He did not like the use of a strict formula for painting, but painted the big impression.

On Sargent:

Gammell, when 23 or 24 years old, met Sargent while going to the opera with friends. Sargent had been working on a charcoal of a girl who Gammell describes as homely, without any real beauty, though she flaunted as if otherwise. The girl had some ability to sing and did so with Sargent at the piano.

They had supper and chatted. Their host suggested that the painters, Sargent and Gammell, talk and have a smoke, which they did. Well, Gammell was filled with admiration at this impressive giant of the art world. He said, "Mr. Sargent, I respect your painting very much." To which Sargent was quite uneasy and then asked Gammell, "Who are you studying with?" "Paxton," said Gammell. "He can draw very well," remarked Sargent. Sargent further stated sometime later and often, "Portraits ruined me!"

This evening Gammell said to me, "You should be very pleased at the way your portrait is coming. Are you?" I said that I was "very happy that I now understand impressionism!"

August 31, 1976, Tuesday

6:17 - I called Tom about Gary's stuff. Evidently left at Fenway studios in Boston to pick up.

Henri Regnault – We don't know how he might have been. Tarbell said he was the greatest artist of the era.

Interior seeing – same as portrait in development. No method, just hit the tone and the furthest thing wrong. Put your objects around in an interesting arrangement – taste.

I worked the entire day on the portrait and at 4:00PM on making the bridge in the woods.

Williamstown, Massachusetts
September, 1976

Sept. 1, 1976, Wednesday

I forgot the newspapers for Gammell. Tom, who usually picks them up, is away.

I worked up the hands area of the picture of Bernie. Gammell showed his anatomical knowledge by naming the tendon areas, etc. Always a treat to hear him on any topic, including anatomy.

When bones are prominent be very careful to delineate it.

Sept. 2, 1976, Thursday

This morning Richard Lack called me by phone to discuss his Atelier show. He wanted at least three pictures from me. He called person to person on Gammell's phone (458-3973, the studio phone). Gammell said to tell them, "Greetings and goodbye."

Gammell invited me back for the next summer, should I wish to return.

Some years later I did return (a couple of weeks before his death) to share plans I had made with a businessman, for an art renewal. He was very excited to see his legacy rekindled!

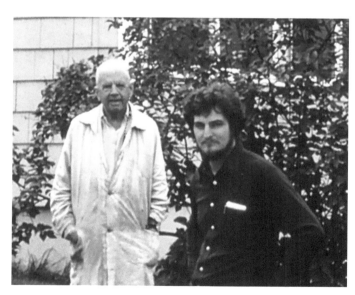

Above: Me with Mr. Gammell, just before my departure from the Williamstown studio in September of 1976.
Right: Me in front of the Fenway Studios in 1988.

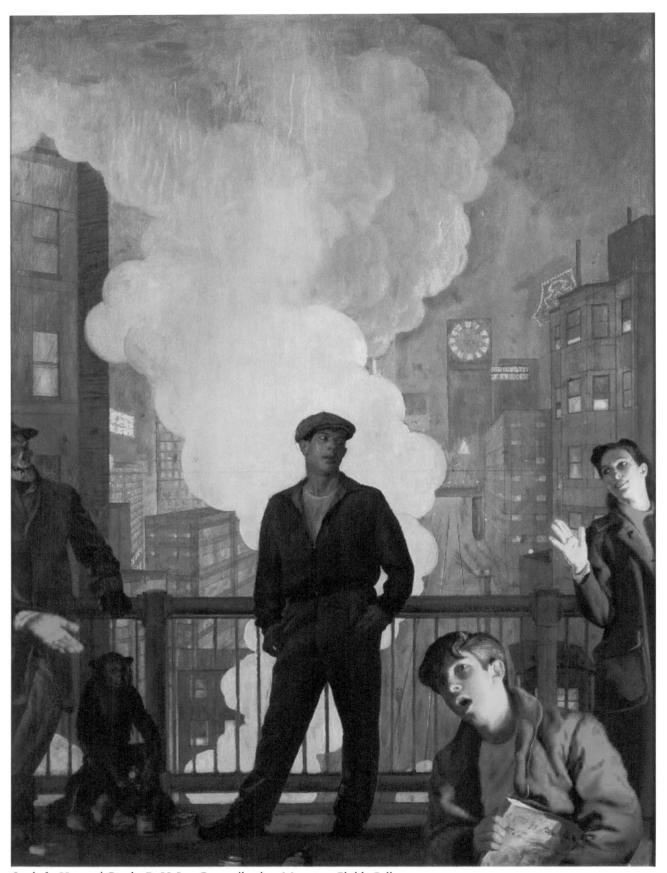

Study for Haunted City, by R. H. Ives Gammell, oil on Masonite, Childs Gallery.

Robert Hale Ives Gammell (1893-1981)

R.H. Ives Gammell was born into a wealthy banking family in Providence, Rhode Island. As a young man, the old standard publication series called Masters in Art would be an illumination to him. It opened up the Art world of the time with biographies and reproductions of respective works. After graduation from the Groton School in 1911, he enrolled in the Museum School of the Boston Museum of Fine Arts. In his autobiography Gammell begins his story by writing, "In search of a Teacher," and his quest would vet several potential instructors toward the goal of refining his talent to paint like the Parisian masters he admired.

The very first artist that Gammell would meet, who happened to have painted his mother's portrait, was James J .Shannon (1862- 1923). Seeing the artist at work in a prepared room at the house was a delight to him and provided real insight into the inner workings of the painter's craft.

While Gammell was already granted entry into Harvard, he was single-minded in his strong wish to study painting. His father, while reluctant to grant him permission to study art, gave young Gammell a one-year trial period to work under a professional artist. This arrangement was proposed by DeCamp (then a highly paid portrait artist) to see if indeed it was a wise course for Gammell to pursue. DeCamp's would be the final word after that time. He would relate it to his father if it would be worthy for Gammell to continue studying art as a profession.

Gammell also notes in his autobiography that those wishing to pursue Art from more modest income families might best discourage their children from it due to the difficult task ahead, whereas the upper classes did not find it altogether inadvisable for their children.

Following the brief one-year study with DeCamp, Gammell formally began following his career path and faithfully so.

His first serious instructor and advisor was William Sergeant Kendall, who also painted portraits of his parents. While growing up, the young Gammell had often viewed the portraits in the home but at the time hadn't yet met him. His initial meeting with Kendall made a lasting impression. Gammell sought him out at his studio on his mother's suggestion.

Mr. Gammell in 1916.
Gammell served in the United States Army under General Pershing. He fought Pancho Villa on the Mexican border.

It should be noted that prior his tutelage under Kendall, Gammell did do some cast work with William Loring. Unfortunately, the level of instruction under Loring was cursory and only over a summer vacation, while Kendall's tutelage would last nearly four years.

After that period, Kendall broke off the association with Gammell. That event ultimately led him to work with William McGregor Paxton. It was to remain a close mentoring relationship until Paxton's death in 1941. During that period Gammell would make the trip abroad to Paris and to the Académie Julian just prior to World War One, only to be forced to return at the outbreak of the war (in 1914) and to resume study in Boston with Paxton.

After Paxton's death it was very apparent to Gammell that so much had been lost in the Art circles socially and in the art school system, in particular, that he felt compelled to get busy both writing and instructing in order to help preserve the tradition he had learned and fought so hard to acquire. The devotion to and regard of those prior artists whose shoulders carried the great western tradition of representational art, having been built up over many generations, was now hanging in the balance. The generation of the early Parisian-trained American painters, coming back home to America, were effectively dying off by the 1930s, and few taught the disciplined craft in its truest form anymore. Many ventured into impressionism and other offshoots but the old solid training was largely passed by. The ensuing vacuum required action so Gammell got busy.

Gammell's seminal book, Twilight of Painting, would be the spark that would ignite the change. It provided an earnest reevaluation of what comprised solid representational arts training. By acknowledging and preserving a number of key artists, how they worked and thought, he gave a new generation insight into the past. He called for a return to the rudiments and discipline of a higher calling and standard, as he himself was taught.

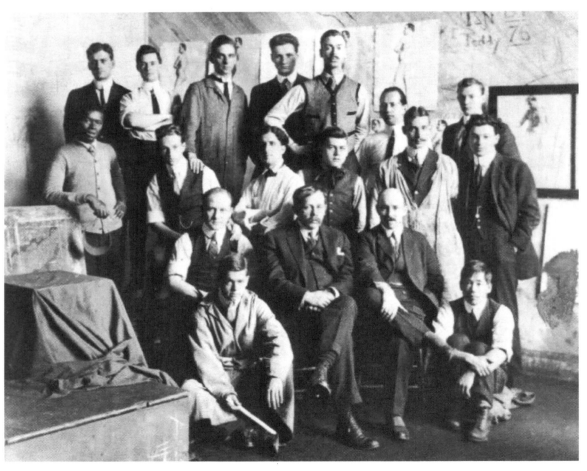

School of the Boston Museum of Fine Arts Life Class in 1913. Gammell is seated in the front-left. Paxton is seated, the second from the right.

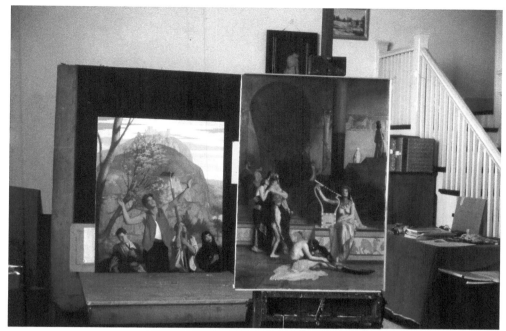

Artwork at Gammell's Fenway Studios, Boston.

Additional written publications by Gammell include, Dennis Miller Bunker, The Shop Talk of Edgar Degas, and The Boston Painters: 1900-1930. Each title provided insights to a period of time, almost lost, and filled the gap only he any longer knew so well. It was a gap perhaps he was meant to fill, with his unique understanding and courage.

His training program began with just a handful of students. At the time he adamantly felt it was the only way to approach the real study of painting. This teaching style would continue until his death in 1981.

As a former pupil, I can attest to the remarkable gift Gammell had. He shared of his time and knowledge when most other artists would long since have retired, or being financially comfortable, felt no need to do more. I had a fruitful period of study with Gammell during the summer months of 1976. A real highlight for me. "To hone my skills", he suggested, and invited me into the fold. After that period, I went on for a few years practicing what I learned from him, as well as learning the business of art.

In 1981, I called again on Mr. Gammell. He was 88 years old, but still very active with students. I wanted to share with him my excitement at the renewed interest in representational art, and the connections being made - artistic inroads that were beginning to take shape at that time. Living in New York, I became involved with several art collectors and Galleries including a number of art associations. Since I had access to circles of influence, I was seeing the shift beginning to take root rather dramatically. The climate was ripe for change, and I wanted to share it with him, to get his blessing and keep the ball rolling, so to speak. Little did I realize he would see it actually unfold in his final years as he did. He was absolutely delighted as I brought with me a businessman, art collector, and friend. That friend, Fred Ross, shared my own interests in establishing a practical, workable plan for nurturing the renewal of traditional representational art, art training, and the reappraisal of 19th century standards. These things where just beginning to be loved again. Fine workmanship was again becoming appreciated, and at a new level. Fred and I met Gammell with those ideals and thereafter got busy.

It was just a couple weeks later that Gammell passed on. A letter to Fred with appreciation of our visit arrived a few days later.

The earnest study and high calling in the craft of picture-making is once again on the rise. This is due, in part, to Mr. Gammell's personal campaign for higher standards through his art, teaching and writing over the intervening years.

Bessie Brooks, Writing, by R. H. Ives Gammell.

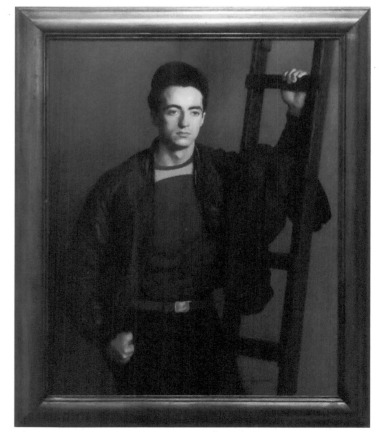

The Janitor Boy, by R. H. Ives Gammell (1942).

Nude, by R. H. Ives Gammell.

The Fates, Beautiful Vision, by R. H. Ives Gammell (1930).

Female Nude, by R. H. Ives Gammell (1930).

Female Nude, by R. H. Ives Gammell.

Portrait Studies, by R. H. Ives Gammell (1961).

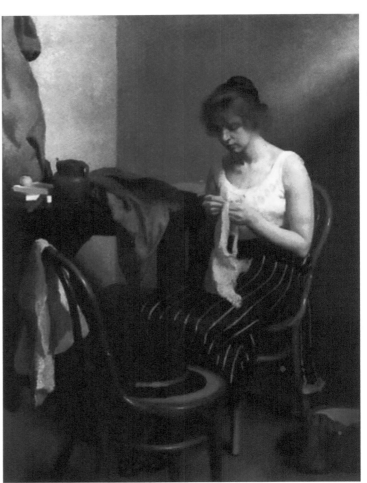

Woman Knitting, by R. H. Ives Gammell.

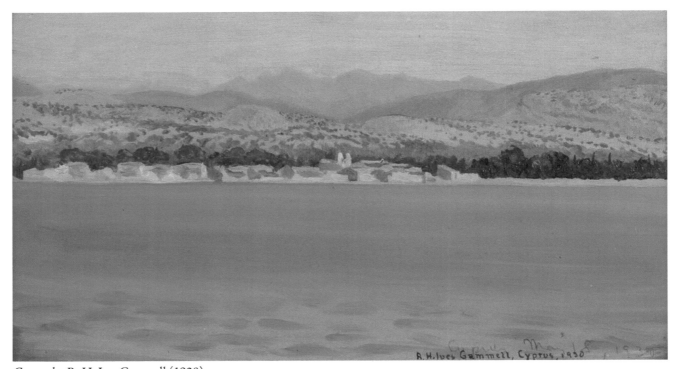

Cyprus, by R. H. Ives Gammell (1930).

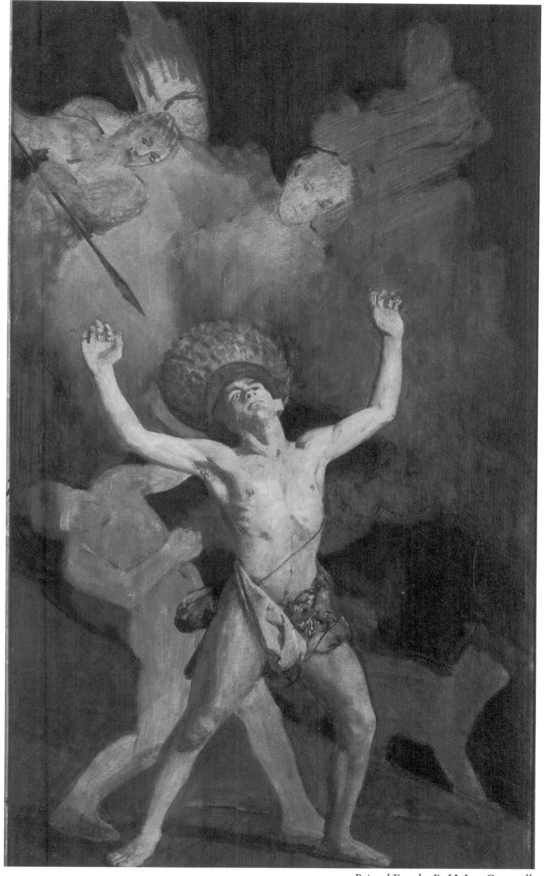

Primal Fear, by R. H. Ives Gammell.

Male Figure, by R. H. Ives Gammell.

Male Nude Studies, by R. H. Ives Gammell.

Study of a Nude by a Tree, by R. H. Ives Gammell.

Hound Series (detail), by R. H. Ives Gammell.

The Captive, by R. H. Ives Gammell.

Harvesters, by R. H. Ives Gammell.

Seated Female Study, by R. H. Ives Gammell.

Male Nude, Out of Doors, by R. H. Ives Gammell.

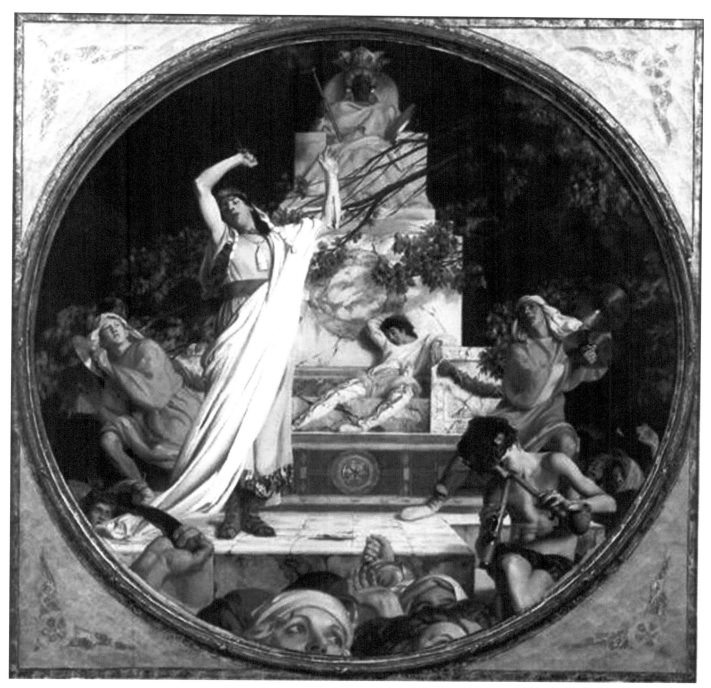

Atys, by R. H. Ives Gammell 1931.

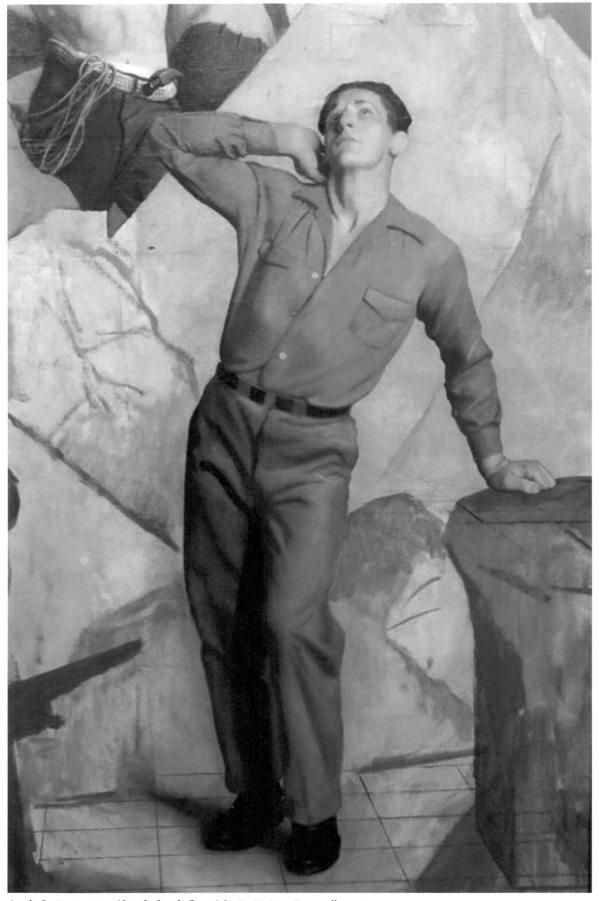

Study for Destruction (detail of male figure), by R. H. Ives Gammell, 1939.

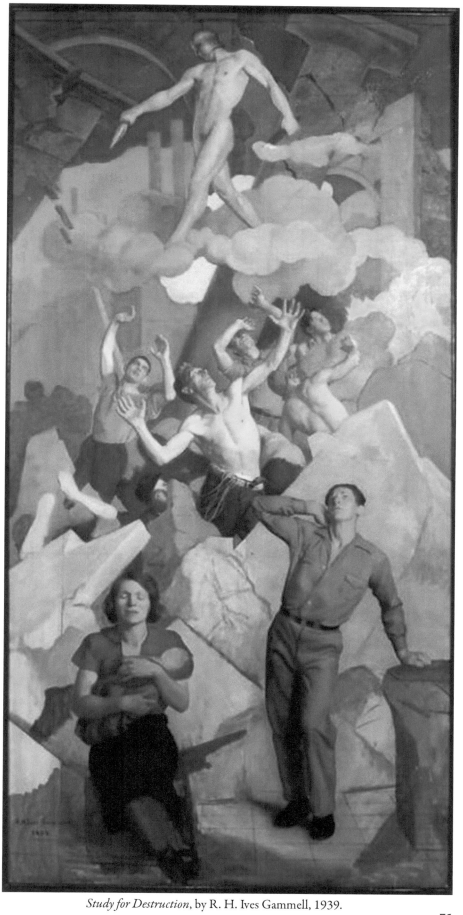

Study for Destruction, by R. H. Ives Gammell, 1939.

The Fruit Stand, by R. H. Ives Gammell.

Portrait of a Student , by R. H. Ives Gammell (1941).

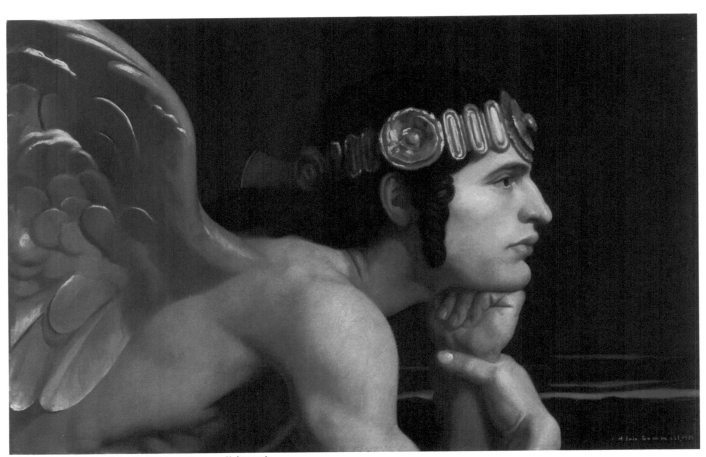

The Destroying Angel, by R. H. Ives Gammell (1935).

Portrait of Roger Irving Lee (1881-1965), by R. H. Ives Gammell.

Mrs. Richard Cary Curtis (Anita Grosvenor Curtis), by R. H. Ives Gammell (1920).

The Law, by R. H. Ives Gammell (1930).

GI, by R. H. Ives Gammell (1946).

Bathsheba, by R. H. Ives Gammell, oil on canvas, 54 12 x 44 14 in (1931).

A drawing by Gammell of a man in Colonial dress.

A drawing by Gammell of a man in Colonial dress.

Two Archers, by R. H. Ives Gammell, drawing.

A drawing by Gammell of a man in Colonial dress.

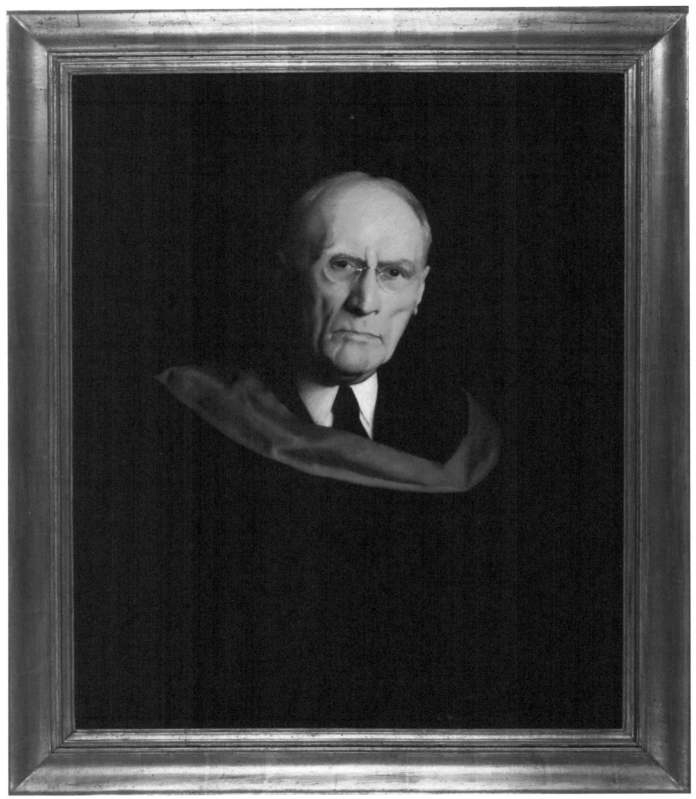

Gammell, Robert Hale Ives
Portrait of Charles Burton Gulick (1868-1962). 1942 Oil on canvas, 31 x 25¼ in.
Harvard University Portrait Collection, Gift of Charles B. Gulick, Jr.
Photo: © President and Fellows of Harvard College

Artists Who Influenced Gammell

Artists within the confines of a productive studio environment are fortunate enough to be able to discuss, analyze and emulate the artists whose past works have lifted the art and craft of painting to the very heights of Artistic expression. In many cases the student of painting may wish to combine their own vision and talents with a blend of the artists' styles they admire. Sir George Clausen acknowledged that it is impossible to combine the qualities of so many artists in the overview of history, but one must look to be guided by those few painters who most closely represent one's interests, otherwise a drifting to extremes results and a loss of cohesion in the artist's oeuvre.

Gammell in his unique position in history was able to live among the heroes we know and admire. He wrote of his early years as a young man in Paris and what exhilaration he met as an aspiring artist before the outbreak of the great war. Accordingly, throughout his lifetime of work and teaching this unique perspective was to give to future generations the wherewithal to correctly practice the craft of painting, fashioned cohesively after tradition. A view wildly differing from contemporary movements of the modernist era, much outmoded today in significance.

Thus, the masters that we discussed within the studio shaped individual development, and Paxton's example would be a guiding influence as well, both in the way Gammell approached teaching and daily workmanship. Gammell's mentor, Paxton, was the youngest of the Boston School painters. Paxton passed on to Gammell the unique blend of academic training and the best of the impressionist movement, an added factor that proved highly beneficial in the training of students and overall effect in picture making.

Interestingly, Gammell, much enamored by the academic painters of 19th century Paris, sought to acquire techniques from both historical and imaginative picture-makers. Frederick Lord Leighton was a favorite of Mr. Gammell from the British side. The profound influences of those styles and developments, aesthetically well-shaped Gammell's early years, and later served him well as a practicing painter. Students who passed through his studio, typically only a very select handful of students, were privy to discussing and learning ways to develop in this unique atmosphere. Degas, for example may be compared to Ingres, who may further be compared to Carolus-Duran, all of whom cultivated a unique group of followers and practices all their own. Duran was heavily influenced by the great 17th century Spanish painter Velasquez, who placed great emphasis on the practice of values in painting. Velasquez was becoming a major influence throughout nineteenth-century Europe with Duran as his chief proponent.

Of the masters discussed in the studio, the prevailing factors were integrity of work, good sound working habits, perseverance over the long haul as a professional, knowing the difficulties artists face, with a certain stigma by society of a better choice of careers. But talent follows its own path. A certain toughness of mind and spirit are absolutes in the artist life. The reward in a job well done is its own profit. John Singer Sargent stated, "To Paint is to Pray." The following pages are a brief glimpse within Gammell's studio, the artists we discussed and analyzed and their contrasting styles and aims. Coupled with a careful study toward nature and good design, our motto's were: "One cannot design better than nature," and "Seek after the overall effect to achieve the 'Big Look.'"

The Garden of the Hesperides, by Lord Leighton (1892).

Flaming June, by Lord Leighton (1895).

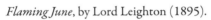

Crenaia, the Nymph of the Dargle,
by Lord Leighton(1880).

Frederic Lord Leighton (1830-1896)

"Every man who has received a gift, ought to feel and act as if he was a field in which a seed was planted that others might gather the harvest" -Frederic Leighton, August 1852.

Frederic Leighton was born in Scarborough, Yorkshire in 1830. His father was a doctor, and his grandfather had been the primary physician to the Russian royal family in St. Petersburg, where he amassed a large fortune. Leighton's career was aided substantially by his family's wealth, receiving an allowance throughout his life.

Leighton's parents did, however, express concern over his career choice as noted in a letter of 1879: "My parents surrounded me with every facility to learn drawing, but, strongly discountenanced the idea of my being an artist unless I could be eminent in art."

Leighton persevered and succeeded. Queen Victoria purchased his first painting in 1855. Eventually, in 1878, he became President of the Royal Academy of Arts. He was also the only British artist to have been awarded a title, becoming Frederic, Lord Leighton, Baron of Stretton.

It is noteworthy that Leighton was not only ambitious in his art but also was a generous teacher as well. One of his pupils, the sculptor Hamo Thornycroft wrote, "He was the most energetic and took the greatest pains to help the students. He was, moreover, an inspiring master."

Leighton was one of Gammell's favorite painters because he was a thorough workman and did not take shortcuts to achieve his highly finished paintings. His was a noble workmanship, a standard every true painter can admire, whatever the style he ultimately employs.

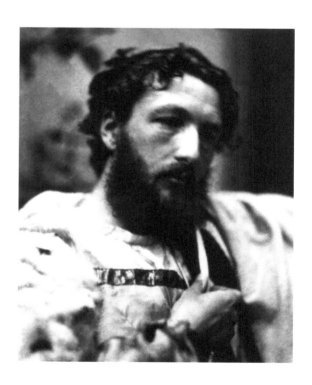

There is an interesting side note regarding Leighton's muse Dorothy Dene (born Ada Pullan - shown as the draped nude on the previous page) who was his model and possibly his secret mistress. He was 50 years old when he met the 19 year old future model. Although speculation was that they were married secretly, nothing is recorded in Leighton's letters. There is mention by artist friends of her being always a partner with him at events, as well as at Leighton's studio. Regardless, it was a mutual relationship which made her famous. It led to her performing as an actress, and when he passed away she received a large pension from his estate as provided in his will. In the annals of art history her likeness is forever intertwined with Leighton's.

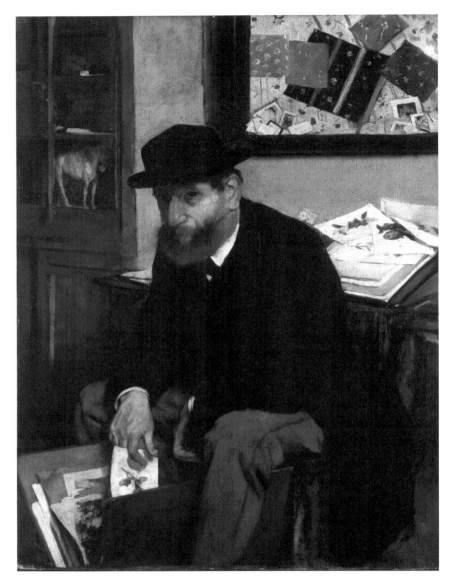

Upper left: *The Collector of Prints*, by Edgar Degas (1866).

Upper right: *Dancer Adjusting Her Slipper*, by Edgar Degas (1873).

Below right: *Portrait of Henri Michel-Levy*, by Edgar Degas (1878).

Lower left: *The Dance Class*, by Edgar Degas (1873).

Edgar Degas (1834-1917)

Edgar Degas was born in Paris, France, into a moderately well-to-do family. He was the oldest of five children. Later in life he chose to change the spelling of his family name, De Gas, to the less formal Degas.

Degas attended and graduated from the Lycée Louis-le-Grand, which was a prestigious secondary school located in Paris. He received a baccalauréat in literature in 1853. He started to paint early in life and even turned a room in his family's home into an artist's studio. He was a registered copyist in The Louvre Museum. However, his father urged him to study law instead. Agreeing to his father's wishes, Degas duly enrolled in the Faculty of Law at the University of Paris in November 1853. He did not care for it at all.

He met Jean-Auguste-Dominique Ingres in 1855. Degas revered him for his advice: "Draw lines, young man, and still more lines, both from life and from memory, and you will become a good artist."

In April of 1855 Degas was admitted into the École des Beaux-Arts. He began study there with Louis Lamothe, (Lamothe was a pupil of Ingres and Jean-Hippolyte Flandrin) under whose guidance Degas thrived. In 1856 Degas traveled to Italy and stayed there for three years. During the trip, in 1858 while in Naples, he began studies for his early masterpiece, *The Bellelli Family*. Also while in Italy he made copies of works by Michelangelo, Raphael, Titian, and other Renaissance artists. In these copies he usually depicted a selection of a detail from their works in his own style.

Instilled into Degas was the strong conviction that memory drawing is vital to one's craft. His ability to remember gestures and refine them where lauded over by visitors to his three story studio. Along with Sargent, and others who adhered to the practice early on, he developed a skill set that became part of the everyday tools of the trade.

In later years he also developed into a sculptor. Unfortunately, many of his sculptures were discarded because of his perfectionism.

Gammell was very much enamored with Degas to the extent that he wrote a book about him: *The Shop Talk of Edgar Degas*.

Right:
The Excommunication of Robert the Pious,
by Jean-Paul Laurens (1875).

Middle left:
Death of Saint-Geneviève, Panthéon, Paris,
by Jean-Paul Laurens (detail).

Middle right:
*The Last Moments of Maximilian Emperor
of Mexico*, by Jean-Paul Laurens (1882).

Bottom:
Death of Saint-Geneviève, Panthéon, Paris,
by Jean-Paul Laurens (1877).

Jean-Paul Laurens (1838-1921)

Jean-Paul Laurens was a major Salon painter of French historical scenes. From 1884 he was also one of the more popular teachers in Paris at the Académie Julian, where he attracted many American students. In fact, Laurens was the most sought-after French teacher among Americans. Laurens emphasis was centered on the study of anatomy "He considered it a most important asset to an artist's knowledge, especially when drawing figures in action from imagination."

Two of his sons, Paul Albert Laurens (1870–1934) and Jean-Pierre Laurens (1875–1932), both also became painters and teachers at the Académie Julian, often filling in for their aging father.

It was Jean-Pierre Laurens (son of Jean Paul Laurens) that Gammell would later exclaim that he wished he would have studied under at the Académie Julian. Instead he was influenced by the Americans there in Paris who largely met at Baschet's classes and urged him to follow. They preferred Baschet because they assumed the teaching being given by Laurens at the time was generally done by his sons as the elder was seldom there.

Jean Paul was the Father whose reputation in France was secure as a Historical painting master but aged by the time Gammell went to Paris. His sons took over the duties and did very well at training another large group of Americans during their tenure.

The exquisite work of the Jean Paul Laurens can be seen today through the murals in Paris: *Death of Saint-Geneviève*, Panthéon, Paris.

Portrait of Jean-Paul Laurens, by his son, Jean-Pierre Laurens (1919).

Portrait of My Mother, by Jean-Pierre Laurens (1902).

Portrait of Mrs. Laurens, by Jean-Pierre Laurens (1921).

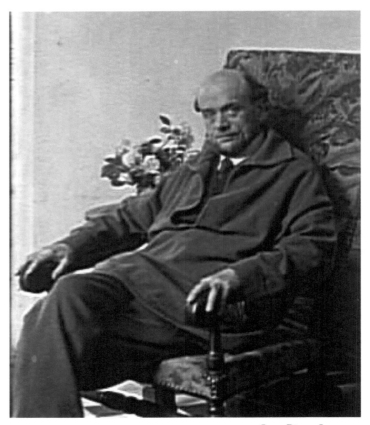

Jean-Pierre Laurens.

Jean-Pierre Laurens (1875-1933)

While a student with Mr. Gammell during those summer months of 1976 in Williamstown, we had the opportunity to talk at length about a number of topics.

On one of those occasions as we walked and talked about his Studio-residence, Gammell mentioned his wish that he may have found in some student similar characteristics to his own (socially, philosophically, and intellectually). It was something he expressed in terms of a similar social status and background he had, it always stuck in my thinking that he must have had some 'one' in mind but I did not give it much more thought, except vividly remembering the conversation.

Then, years later while reading Gammell's autobiography, I read that he felt remorse in having passed up a opportunity to learn from the artist Jean-Pierre Laurens when he was a young student in Paris, just prior to the outbreak of WWI. Jean-Pierre was teaching at the Julian Académie at the time. He was the younger son of Jean Paul Laurens, the famous artist and instructor. During the heyday of the 1880s, Jean-Pierre and another son, Paul Albert, took over the classes for their father who had retired from full time teaching. Both sons were exceptional artists in their own right and they often assisted him on his mural commissions in Paris.

Jean-Pierre Laurens, was of the same social standing as Gammell. It was comprised of an elite class of poets, artists, and intellectuals of the Parisian society in the day. As the story goes, Gammell was persuaded by the American students studying in France to join the class of another atelier rather than those classes offered by Lauren's sons. Over the years that followed, Gammell said it was the one regret he had over his long career, to have met and be mentored by Jean-Pierre Laurens and establish a cordial rapport of mutual interests and social similarities. He never did.

In looking more closely at Jean-Pierre Laurens' life, of which little is known today, there is a detailed episode of his capture by the Germans during the outbreak of WWI. Laurens spent the entire wartime period as a prisoner of war. That experience took its toll on him and he witnessed the atrocities committed on prisoners and the appalling conditions in which they suffered. His best friend, the French poet, essayist, journalist, philosopher, and playwright, Charles Péguy (1873–1914) died during his incarceration.

After the war Jean-Pierre was a changed person, but he tried to reestablish his artistic life in its wake. France suffered dramatically as the cultural center of the world, with wartime conflicts and the horrors it brings. Earlier, in 1870, the Franco-Prussian War took the life of another young artist, the celebrated Henri Regnault. It was a true tragedy felt all over France. Bastien- Lepage was also wounded in the head during that conflict. Struggle vs Beauty.

Thinking back on my conversation with Mr. Gammell is altogether fascinating. After reading of his search for just the right teachers early on in his artistic development, his longing for that unique reciprocal relationship with such artists as Jean-Pierre Laurens, a painter and perhaps a kindred spirit of shared interests now makes perfect sense to me. It is a puzzle now solved, in my own mind at least, from that morning walk and conversation with R. H. Ives Gammell. It is part of his personal story and revelation to me.

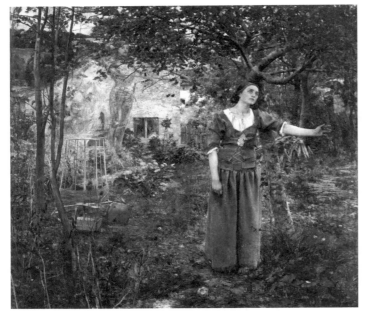

Top left: *Joan of Arc*, by Jules Bastien-Lepage (1879).
Top right: *Joan of Arc*, (detail).

Middle left: *October*, by Jules Bastien-Lepage (1878).
Lower left: *October*, (detail).

Lower right: *Portrait of My Grandfather*, by Jules Bastien-Lepage (1874).

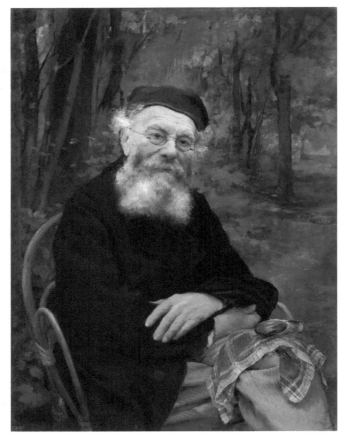

Jules Bastien-Lepage (1848-1884)

Jules Bastien-Lepage was born in 1848, in the region of Damvillers France. His family, although poor, did encourage him early on to draw. Despite that encouragement, they did not really expect him to pursue art professionally. Jules persisted, however, and attended the École des Beaux-Arts in Paris. Since his family did not have the means to support him financially, he was able to secure work in Paris as a postal clerk while attending the École part time. The plan did not work out well and he soon quit the job in order to attend school full time. He used his skills as a painter to sketch for food and other necessities. These were times of real struggle for him to finish out his studies, but his commitment was firm.

During his student days in Cabanel's classes, Jules was a companion to Dagnan-Bouveret, Albert Edelfelt, and Julian Alden Weir, particularly. They often ventured off to the cafes, talking about art, current trends and their future plans.

Jules served in the French military during the Franco-Prussian war of 1870. A bullet fragment grazed his forehead and he was forced to return home to recuperate.

During the summer of 1873 he began his remarkable *Portrait of My Grandfather*. The painting was done in his family's garden, working out-of-doors. When he exhibited it in the Salon, the Portrait astonished the visitors for its clarity, color and high finish, just the opposite of the impressionist artists who were also making their voices heard at the time.

Jules' portrait of his grandfather received a third class medal. Additionally his second entry to the same Salon was of an imaginative nature called, *Le Chanson de Printemps* (A Spring Song). The French government purchased it, thus establishing his reputation as a real force in French artistic circles.

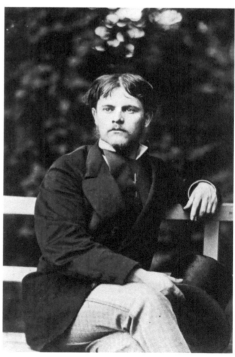

Jules' seminal work was *Jeanne d'Arc* (Joan of Arc), the maiden heroine of France, from the Lorraine region, from which both Jules and Joan came. It is said he repainted Joan's head many times over, scraping down the previous version to make it anew. It was also enlarged from the original concept that centered primarily on Joan, with the trees around her. By adding more canvas later, he included the angelic figures. When asked of Jules what was his secret, he simply said , "Concentration is the secret of good art."

Dagnan-Bouveret, in remembering his colleague Bastien-Lepage, said, "Ah, let us talk about Bastien! He is always present with me, and whenever I paint a new picture I ask myself if it would have satisfied him."

Roadside Cottage, by Dennis Miller Bunker (1889).

Jessica, by Dennis Miller Bunker (1890).

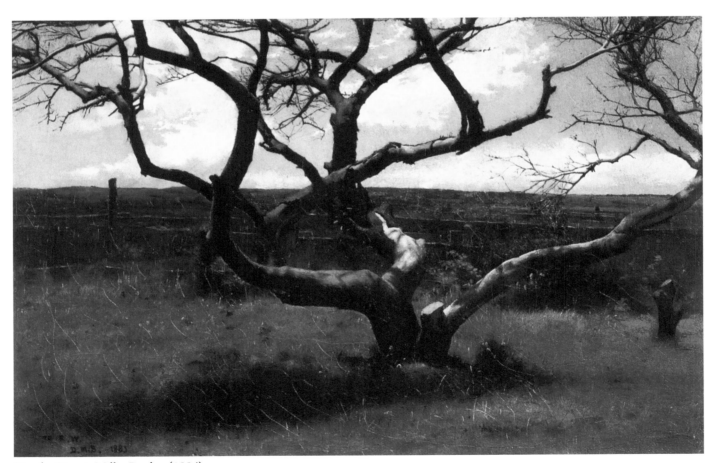

Tree, by Dennis Miller Bunker (1884).

Dennis Miller Bunker (1861-1890)

Dennis Miller Bunker was born in 1861, in New York City. In 1876 he enrolled at the Art Students League of New York. By 1882, Bunker had left New York in order to study with Jean-Léon Gérôme at the École Nationale Supérieure des Beaux-Arts, in Paris. Apart from his studies in the atelier, Bunker would travel the French countryside painting with two other companions. He would eventually settle in Brittany for more serious picture-making.

Gammell suggests that Bunker, while a student in Paris, picked up a polished and well-rounded social etiquette. This only added to his natural charismatic charm and handsome features. Upon his return to America those qualities were admired in Bostonian circles, which led to offers to teach as well as entrée into the various art clubs that were burgeoning at the time. One such meeting place was the St. Bololph Club where it is supposed that he met with

John Singer Sargent. The two became fast friends, so much so that Sargent asked Bunker to join his family as they vacationed in England at Talcot. Pictures by Sargent of Bunker vividly record their lively camaraderie.

Gammell records more on the life of Bunker is his book on the painter, simply titled: Dennis Miller Bunker, by R. H. Ives Gammell.

Bunker was a natural talent who was much appreciated in his day and afterwards. Sargent spoke of him as having more natural gifts than any other American painter. His summer landscapes of marshes and ponds were a marvel to the new style of painting that he gleaned from Sargent. Bunker's style influences the other Boston School painters, many of whom had close ties to Monet. It would alter the direction they took their painting.

Bunker's life was cut short far too soon. He died at the age of 29, ostensibly the result of spinal meningitis. But the impact of his talents are forever recorded in his glorious pictures of people and nature.

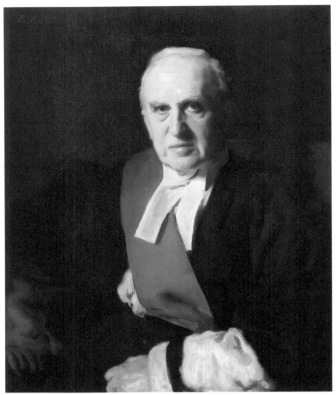

Charles Russell, by John Singer Sargent (1899).

Portrait of John Millet, by John Singer Sargent (1892).

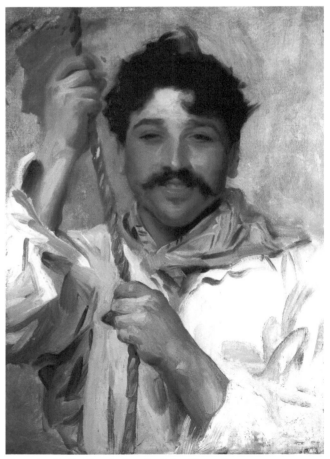

Portrait of a Smiling Italian, by John Singer Sargent.

Portrait of a Gondolier by John Singer Sargent.

John Singer Sargent (1856-1925)

Without question, John Singer Sargent is considered one of the finest artists of any generation. He was born in Florence, Italy in 1856, of expatriate American parents. His influence extends from his time all the way up to today. He was noted for pioneering what is called, The New Art, and brought a fresh approach to the craft of painting.

Beginning with his early years in Carolus-Duran's atelier in Paris (he attended for approximately 4 and a half years) and also in Leon Bonnat's atelier, Sargent quickly rose above his peers and never looked back. His ability to draw shapes accurately and with a confident brushwork identifies him closely with the earlier Franz Hals and the Spanish Velazquez, both of whom Sargent told students to learn from. He had a highly successful portrait career in Paris, and eventually moved to London where he devoted some time during each year to teaching. "Work out the form," he exhorted his students at London's Royal Academy.

Sargent was a very disciplined draughtsman. His heroic energy was attested to by many of his associates in the art world, and also of authors that knew him. Gammell expressed his own admiration for Sargent in that he was able to pull off so many large masterpieces without the help of student-apprentices. He also was in awe of Sargent's yearly output, which numbered into hundreds of paintings in addition to the accompanying studies.

The work ethic Sargent engaged in was made possible by the direct method of the day: Sight-Size. This prearrangement of his portrait setups, along with memory exercises, played crucial roles in his ability to quickly and straightforwardly see what was in front of him and record it. Carolus-Duran was an exponent of the practice and instilled it into his students. Working with a canvas beside a model, and venturing back a number of feet to see the ensemble, was the key to correctly record shape, value, and color as they appear to the artist's eye. Likewise, Gammell and William Paxton made it a practice in their own work and with their students.

On a personal note while visiting London (1983) I ventured to the Witt Library where images are kept in photo-form of artists' works covering a vast time period. As I sought out boxes containing the work of Sargent, I was astonished at a whole shelf full of boxes each containing many photos of works by Sargent. I poured through several of them, as time permitted, and saw countless photos of portrait drawings and studies. It became apparent that the shear effort involved by Sargent in drawing face after face was incredible. I was not only amazed by the quantity of work, but the quality of it all added a whole other dimension to the man.

"To work is to pray," was a favorite saying of Sargent's. That saying alone helps us understand his work ethic. The notion that Sargent 'dashed things off' is erroneous. For with knowledge comes certainty, and careful study gets the job done while making it seem effortless. The fact that Sargent discarded so many portrait sittings repeatedly (he often referred to them as 'false starts') one after another, testifies to his real power to 'do it right' no matter how many times one requires to do a job.

The Pear Orchard, by Joseph DeCamp (1895).

The Listener, by Joseph DeCamp (1904).

Sally, by Joseph DeCamp (1907).

The Blue Mandarin Coat, by Joseph DeCamp (1922).

Joseph Rodefer DeCamp (1858-1923)

Joseph Rodefer DeCamp was born in Cincinnati, Ohio, in 1858. He studied with Frank Duveneck and also attended the Royal Academy of Munich. From the late 1870s until 1883 he traveled to Munich, Florence, and Venice with a group led by Duveneck. That group came to be known as 'The Duveneck Boys'. DeCamp was thoroughly schooled and developed into one of the great American painters of his day.

He eventually settled in Boston. Except for a single year of teaching at the Pennsylvania Academy of Fine Arts, in Philadelphia, Pennsylvania, DeCamp remained in Boston. There, he and taught at both the Museum School and the Massachusetts Normal Art School until his death in 1923.

Gammell stated that he relied heavily on the advice and encouragement of DeCamp. When both were in Paris, on their many trips to the Louvre, DeCamp would share his observations on the great Masters with Gammell. Gammell, in turn, made many social connections possible for DeCamp.

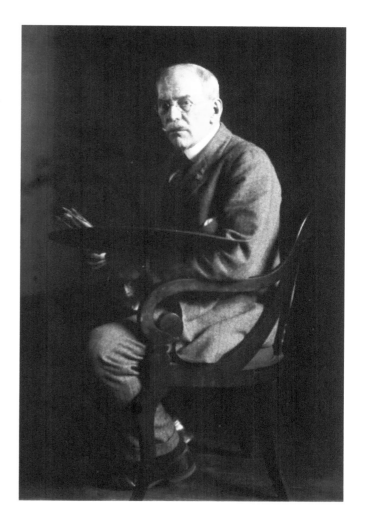

In 1904 a fire swept through DeCamp's Boston studio at the Harcourt Building. It destroyed several hundred of his early paintings, including nearly all of his landscapes. Other artists also lost work in the fire.

The Fenway studios were built following that disaster. Fenway became the home of Gammell's studio, along with many other artists. Architects Parker and Thomas designed Fenway Studios. Each of the 46 studios had north light, 12 foot high windows, 14 foot high ceilings. The studios on both ends also had fireplaces.

DeCamp was held in high esteem by collectors and his fellow artists. 'Work' was the word passed down to DeCamp and his comrades while under Duveneck's tutelage and he gave them the following instructions: "Now, I don't want any geniuses in this class; but what I do want is a crowd of good workers." "This is the thought I have always tried to instill in my pupils," said Mr, Duveneck. DeCamp took that admonition to heart. His consummate workmanship is unmistakable when viewing DeCamp's paintings.

The Other Door, by William McGregor Paxton (1917).

Mabel Fuller Blodgett, by William McGregor Paxton.

The Green Dress, by William McGregor Paxton (1924).

Figure Drawing, by William McGregor Paxton.

William McGregor Paxton (1869-1941)

William McGregor Paxton was born in Baltimore, Maryland in 1869. He taught at the Boston Museum of Fine Arts School from 1906 to 1913. After his Harcourt Street Studio burned down in 1904, Paxton moved to Boston's Fenway Studios for a brief period but then moved on to the Riverway Studios, also in Boston.

Paxton attended Cowles Art School on a scholarship which he attained at the age of 18. He studied with Dennis Miller Bunker at Cowles and then went to Paris to study under Jean-Léon Gérôme (at the École des Beaux-Arts). He also studied at the Académie Julian in Paris. After his return to the States, he went back to Cowles where he studied with Joseph DeCamp. DeCamp also taught Elizabeth, Paxton's future wife.

Paxton became engaged to Elizabeth Vaughan Okie in 1896 and they married on January 3, 1899. They traveled to Europe and upon returning home they spent summers on Cape Cod and Cape Ann. They lived in Newton, Massachusetts, first on Elmwood Street with his parents. They later purchased a house in Newton Center on Montvale Road.

During their marriage, Elizabeth continued her studies with Paxton. She also proved to be a fine administrator, maintaining their books and helping to secure a stable home life. Elizabeth posed for many of his pictures and her beauty was noticed by the other painters as well.

Paxton told Gammell that Gérôme as a teacher was concise and the classes were small. He gave careful attention to each aspiring artist. That was Paxton's experience in the 1890s, but the subsequent years saw very large classes with too many students for the master to attend to for more intimate training.

Paxton explained, "It is really the artist's task in the world to give the public what it wants, but to make the thing better than the public knows it is. In this way we all get educated to like the better things."

In an *American Art News* review of his show at Folsom Galleries, New York in early 1919, Paxton is praised by the magazine. "In this, as in all of Mr. Paxton's work, his skillful technique, fine drawing and a certain quality that he has in common with artists of the modern (not "modernist") French school, are admirably exemplified." His work was rarely shown in New York but his pictures were well received there when exhibited.

In 1941 Paxton passed away at his home while working on an interior painting of his wife.

Girl Among the Hollyhock, by Allan R. Banks.

Boy with a Scythe, by Allan R. Banks.

Allan, plein-air painting in a Boston Garden, during the 1990s.

Allan R. Banks

Allan R. Banks has been the recipient of the Elizabeth T. Greenshields Memorial Fellowship in 1972 and 1973, the Stacey Award in 1974 and later, an Ohio Arts Council Award.

Comprehensive classical training under Richard Lack and later, R. H. Ives Gammell at his private studios in Williamstown, Massachusetts, contributed substantially to the development of Banks' work. Visits to Europe brought about a further development in the direction of his art and a rediscovery of the role of plein-air painting most particularly as practiced by Bastien-Lepage. William Bouguereau became an early influence who exemplified for Allan, the very height of classical knowledge and technical perfection. Added to the most admired workmanship in 19th century France, was the robust painterly works of John Singer Sargent. With these standards in mind he diligently sought to put into practice out door figure painting, with their example to emulate and thoughtfully make his own.

Richard Lack wrote, "Allan Banks is one of America's finest living plein-air figure painters", for the Tampa Tribune newspaper. He has exhibited widely in galleries and museums across the country with numerous works in private and public collections including the Wadsworth Atheneum in Hartford Connecticut, The Newark Museum, and The Springville Museum. In September 1996, Banks was one of a group of six American artists to be invited to work and exhibit with the Union of Russian Artists in Moscow. Additional Group shows included two exhibitions in Dallas, Texas (1980s) with the accompanying Book entitled Realism in Revolution, which followed, coordinated by Richard Lack. Allan further contributed articles and featured in the Classical Realism Journal, a quarterly publication of the 1980s.

A publication of his works as prints and posters has attracted an international following of dealers and collectors. Publications of his work include a cover artist feature in American Artist Magazine, August 1987. Mr. Banks has lectured at the Met museum of NYC through the Portrait society groups. His work was part of the group of artists who created art work for the book, Star Wars Art: Visions, 2010. His artwork titled Celebration of Naboo Youth on Freedom Day., The painting was selected and purchased for the Lucas foundation permanent collection. Additionally, listed in Who's Who in American Art, Who's Who in America, Who's Who in the Southwest and the Dictionary of International Biography. He is currently on file in the Smithsonian Institution, the Witt Library in London, the Capital Hill Club and the White House in Washington, D.C. Featured artist with Rehs Galleries, NYC., FADA shows NYC-LA.

Mr. Banks paints a variety of works ranging from portraits, figurative compositions, interiors, to garden paintings. A memorable group exhibition was at the Hillsdale College Museum, 'America Seen', October 2004, Hillsdale, MI. Also featured in the group exhibition; 'Realism Now- Mentors and protégés', Vose Galleries, Boston, MA., 2004. Richard Lack and Allan Banks with accompanying catalog.

Allan currently resides in Florida with artist wife Holly Hope Banks.

Girl with a Lute, by Allan R. Banks.

Song of Summer, by Allan R. Banks.

Portrait of a Young Man, 19 x 12 in. Charcoal on paper, by Allan R. Banks.

Communicant, Homage to Bastien-Lepage, oil on canvas 40 X 30 inches, by Allan R. Banks.

A seminal work that reflects the artist's Naturalism in a 21st-century context. Inspired by the leading French Naturalist painter Jules Bastien-Lepage (1848-1884). Private Collection, exhibited widely by REHS Galleries, NYC; FADA Shows-L.A.; Trees Place Galleries, Cape Cod, MA.

One must go after the modeling like a fly crawling over a piece of paper.

Jean-Auguste-Dominique Ingres

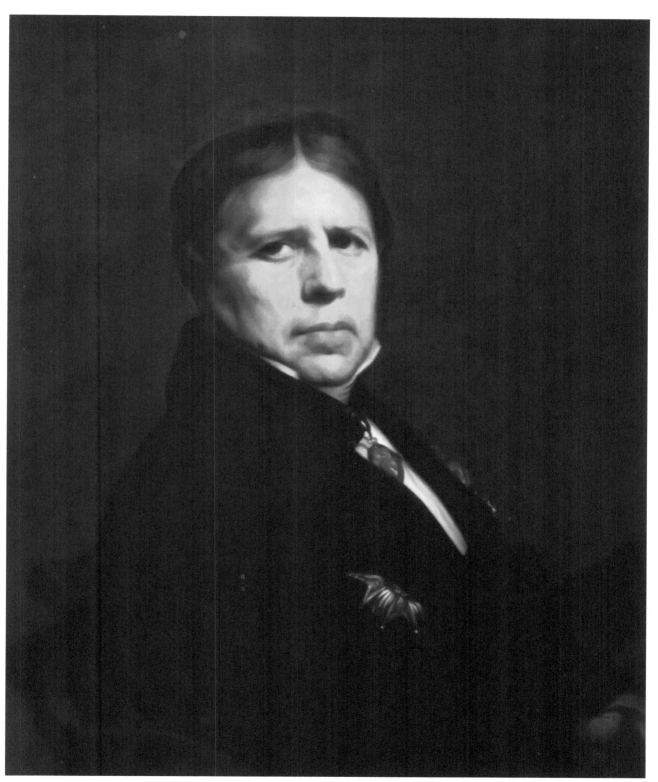

Self Portrait at Age Seventy-Eight, by Jean-Auguste-Dominique Ingres (1864). Royal Museum of Fine Arts Antwerp.

Richard Lack and Allan Banks in discussion during an exhibition. The Third Classical Realism Conference, Symposium and Salon, sponsored by The American Society of Classical Realism, and hosted by Heritage Art Gallery, Alexandria, VA, May 1992.

"The finest things can be accomplished when strong collaborations are formed that see a thing through to the finish."
Allan R. Banks

Holly Hope Banks, Allan's wife and partner on an artistic journey, and aide in the Gammell project. Holly's excellent eye for accuracy and organization are extraordinary.